The Spirit of Children

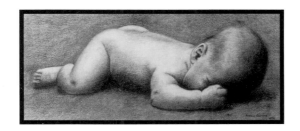

The Spirit of Children

THE ART AND LIFE OF
KAREN CARRINO

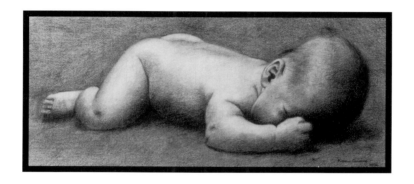

Compiled by Deborah Carrino,
with an Introduction by Marilyn Green

 Prometheus Books

59 John Glenn Drive
Amherst, New York 14228-2197

Published 2000 by Prometheus Books

Inquiries should be addressed to
Prometheus Books
59 John Glenn Drive
Amherst, New York 14228–2197
VOICE: 716–691–0133, ext. 207
FAX: 716–564–2711
WWW.PROMETHEUSBOOKS.COM

04 03 02 01 00 5 4 3 2 1

Library of Congress Cataloging-in-Publication Data

Carrino, Karen, 1953–1972.
 The spirit of children : the art and life of Karen Carrino / compiled by
Deborah Carrino ; with an introduction by Marilyn Green.
 p. cm.
 ISBN 1–57392–811–9 (cloth : alk. paper)
 1. Carrino, Karen, 1953–1972. 2. Artists—New Jersey—Biography.
3. Children in art. I. Carrino, Deborah. II. Title.

N6537.C34464 C37 2000
709'.2—dc21 00–040661

Printed in the United States of America on acid-free paper

In loving memory of

Karen, Michael, and Lisa,

and to the family and friends in whose hearts they still live.

ACKNOWLEDGMENTS

I would like to express my gratitude to all the people who own Karen's work, for their memories and stories that inspired me and their graciousness in allowing me to photograph their pieces for this book and borrow them for exhibitions.

I also offer my thanks to my family members for their contributions and support, particularly because it has been a difficult and painful ordeal most of the time. I am particularly grateful to my sisters: Joan Carrino and Michelle Carrino-Warburton for contributing their secretarial skills and their work during exhibitions, and Barbara Carrino for her help returning works to owners after exhibitions.

This work would never have been completed without the help of my friends: Frances "Bean" Collins, who believed in this book from the very beginning to the end and worked tirelessly with me for years; Paul Felder, whose wonderful proposals to museums, publishers, and the news media worked more often than not; Gail Ruggieri, who catalogued Karen's art

with wonderful patience and hard work; Patricia Morale, James Wittes, Kelly and Tim Shepherd, Barry Burns, Paula Frasier, Rebecca Mandatta, and Pekka Korpijaakko, for their tremendous help with the exhibitions of Karen's work that preceded this book.

I am very grateful to Alan Protas and Jill Adler for defraying some of the costs of this project, and to Johnson & Johnson for providing funds, framing much of Karen's unframed work, and furnishing a beautifully catered opening for their exhibition of her work.

I would also like to acknowledge the valuable assistance of the many newspapers and television media people, whose work helped so much in my search for Karen's art.

My heartfelt thanks go to: Xiao Jun Lee, who was moved to offer her services to photograph Karen's work for this book; Bill Knox, who volunteered his services as a lawyer; Jessica and Zeljko Skropanic, who set up a Web site to help in the search for Karen's artwork; and Dr. Charles Konia, without whose support and guidance through the years I might not have been able to do this.

THE LIFE OF KAREN CARRINO

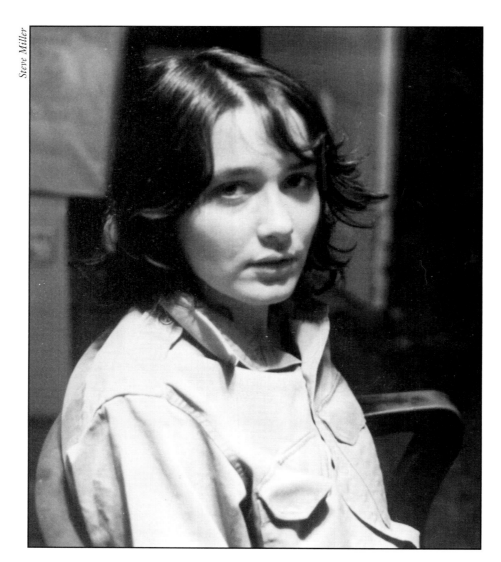

KAREN ROBERT CARRINO
December 4, 1953–December 9, 1972

T he extraordinary work in this book is the result of the recreation of a young life that ended in 1972, when nineteen-year-old Karen Carrino, her eight-year-old brother, Michael, and three-year-old Lisa Boudrie died after their disabled car was struck by a hit-and-run driver. This five-year outpouring of Karen's love and insight through art, mostly images of children, was painstakingly brought together by her sister, Deborah. Unable to resuscitate Karen after the fatal accident, Deborah is, in a sense, doing it now—not giving her the remaining years of the life she'd begun, but achieving the fulfillment of her vision by allowing people to see, through her eyes, the spirit of children. As you share Karen's insight through this book, you are a part of that fulfillment.

One month after Karen's death, her distraught father held an exhibition of most of her work at Memorial High School in West New York, New Jersey, where she had recently graduated. The money from the sale of her work was given to two young artists in her name.

Each sibling had kept some of Karen's art, but the family watched helplessly as Karen the artist disappeared in the wake of Karen the individual.

When her sisters Irene and Deborah later reproached their father for letting the work leave the family, he responded that it needed to be seen on people's walls, not hidden away in portfolios. Deborah's feeling was that, in truth, he could not bear to look at Karen's drawings and paintings, and that this was his way of dealing with his grief. In Deborah's eyes, the family had again lost her sister, who made no distinction between her life and her work.

> *We were in a daze, and when we began to come to, the accident had taken everything. Karen was gone, and so, too, was her work, and we didn't know where it was.*
>
> —Deborah Carrino

Robert Carrino died in 1985, and five years after his death Deborah, who by now was well established in her own artistic career, was increasingly absorbed with the idea of finding and photographing her sister's work, and ensuring that it would be seen. She began talking to her family about searching for the missing pieces, an idea that met with resistance at first. They felt that old wounds would be reopened, that the desire to find Karen's work was unhealthy, and that Deborah should continue to put her energy into her own art after so much time.

> *I decided in 1990 to search for Karen's work, originally to do a photo portfolio for the family. There had been so much frustration, showing the work we had to friends and always having to say, "You should see the rest."*
>
> —Deborah Carrino

In the years that followed, Deborah began her long quest (not yet ended) to find people who owned Karen's drawings and paintings and, in doing so, discover pieces of Karen's life that she had never known. Through the recovered images of children she loved, and paintings of public figures and imaginary children, the fragments of Karen's inner life were being drawn back together as Deborah became the archeologist of her sister's life and work.

> *It was seventeen years after the accident and I didn't know where to begin. No records of the sale of her work had been kept. All I had to go on were twelve photos taken at the sale by Millie Boudrie, the mother of the three-year-old who died with Karen, and they didn't include everything. I had no idea how many pieces were out there or the enormity of what I was about to embark on.*
>
> —Deborah Carrino

Deborah started with those pieces that were still in the family. She took photographs of everything, and then went on to relatives and friends who she knew had some of Karen's work. She called Karen's high school and spoke with the art teacher, who put out the word through the school. Six pieces emerged, followed by more, including one remarkable piece the librarian had taken home to keep from harm, which she gave back to the family (see p. 157).

> *She has a great delicacy, she was trying to find a way out of the generalized way of seeing people using photographic conventions, the dilemma of young artists; she was already grappling with this, trying to find a way out of generalized conventions.*
>
> —Michael Peglau, Studio Arts Faculty,
> Drew University Department of Art

Deborah turned next to the local newspaper, which ran a front-page story on her search.

I was flooded with phone calls from people who possessed pieces, friends, and well wishers. It was a very emotional time for me. There were several messages already on my answering machine when I got home from work that day; they were so wonderful that I kept the tape.

—Deborah Carrino

Newspapers all over the state picked up the story. Karen's work had spread over the eastern seaboard and even to the Midwest. Her drawings hung in the homes and offices of doctors, teachers, judges, a nun. People came forward with their pieces, their stories, and their support. Teachers put Deborah in touch with Karen's classmates; friends, with other friends; and her father's colleagues, with his coworkers.

We've all become like an extended family—they come to all the exhibits. . . .

—Deborah Carrino

Besides the growing network of inquiry, there were some completely unpredictable incidents that brought Karen's work to light. One of the strangest turned up more than forty pieces.

After Dad died, my stepmother moved. There was little communication between us at that time. Dad's landlord called Barbara to say that some work had been left behind, and she went over with my brother Robert. They went through the apartment and found, thank God, that Dad had a portfolio up in the attic, full of Karen's work.

—Deborah Carrino

Deborah found that some of Karen's drawings and paintings were hung in places of honor: in a dean's office, a judge's chambers, in doctors' offices. Most owners were deeply moved and supported the project, freely allowing Deborah to photograph her sister's work. One by one, through word of mouth, paid searches, articles in the *New York Times* and other publications, and television news media, word about the project spread. Deborah rediscovered 278 of Karen's drawings and paintings; she estimates that around 100 pieces are still in unknown hands. As she realized the enormous volume of Karen's work, she felt closer to her father's decision to place Karen's works where they could be seen and appreciated, even though it meant that they would leave the family.

I found more pieces than I ever knew about, including more drawings of adults than I ever realized she did. The more I found and realized how many people were enjoying them, the more I understood my father's reasons for the sale.

—Deborah Carrino

Every time a new piece emerges it's so exciting. As I began going to people's homes to photograph the work, the idea of making a book blossomed. It was as if I were seeing her work for the first time. By this time I had some education in art and could look at her work differently than when we were teenagers. Whenever I looked through the lens to take a picture of another piece, I found myself saying, "My God, how beautiful!" Her draftsmanship, her mastery of many media, the fact that she was self-taught, and the sheer amount of work made me feel that I should do a book. I listened to people's memories of Karen and had them mesh with mine. I knew Karen was special, but to hear it over and over from others also played a part in my decision. It made me feel that her life and work deserved recognition.

—Deborah Carrino

At the urging of Sarah Henry, an art historian at Drew University in Madison, New Jersey, who was deeply impressed with Karen's work, Deborah began to arrange exhibitions. The search for Karen's work for the benefit of her family had turned into a project requiring the skills of a detective, a photographer, and an agent.

> *The exhibitions helped get more coverage, which in turn helped flush out more pieces. As each one came to light, I found people's memories of Karen to be like a heart massage, and so in a way it has been a healing process for me.*
> —Deborah Carrino

> *I'm so proud of my sister Deborah for doing this. . . . Karen deserves a place— she was taken too soon. I was only thirteen when Karen died, and the gathering of her work has given me a chance to know her so much better than I did.*
> —Michelle Carrino-Warburton, Karen's sister

Karen's love for children and her ability to explain their needs (see p. 106) was matched by humor and acceptance. She could tell her father, who felt that children needed to fear in order to respect, that it was giving love and respect that produced it in return. He listened, even though he disagreed. For a person so young and passionately conscious of wrongs to the helpless, she had the rare ability to remain centered and compassionate toward those who violated their feelings. She used humor and understanding to communicate and reach them. This would be extraordinary in the woman of nearly fifty that she would be today if she had lived; it is phenomenal in a teenager. In a way, she was ageless; she was basically the same person throughout her life.

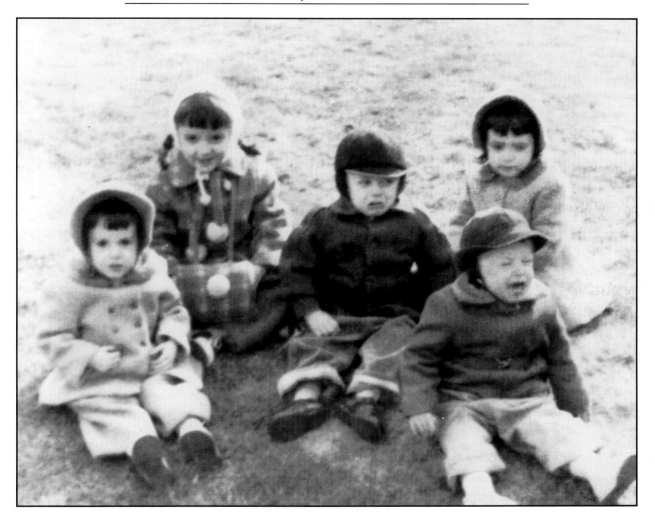

KAREN, IRENE, AND DEBORAH WITH COUSINS KENNY AND JIMMY
1958, Jersey City, New Jersey

From the time she was born, Karen always was the mother of the world. She never acted like a child. She was completely trustworthy and a real friend as well as my daughter.

—Ethel Carrino, Karen's mother

Karen was born December 4, 1953, in Union City, New Jersey, the second child in a family of eight. As a toddler she exhibited the main elements of her personality clearly: the desire to help around the house and keep her environment organized, clean, and disciplined; the love and protection of those around her, especially the defenseless; a warm sense of humor and a wit as perceptive as her ability to nurture.

The photo on page 17 of a very young Karen demonstrates this clearly, showing the reactions of the three sisters, Irene, Deborah, and Karen, to their father's harshness. In order to force the children to pose as he wanted, he had caused her two young cousins to cry. While Irene tried to do the right thing by smiling and Deborah can be seen sitting quietly terrified, Karen refused the camera and the picture in disapproval; she is closed and has shut out the whole project.

The empathy Karen so strongly displayed was a double-edged sword; when she was three or four her parents had a very intense fight, and she had a panic reaction followed by an extremely nervous stomach. Her doctor urged her parents to be careful not to subject her to such emotionally charged scenes. She sucked her thumb into her thirteenth year, the year she began to draw and paint.

Karen's central quality was sensibility, not just sensitivity—a deep affinity for those living things which are open and unspoiled: children and animals, as can be seen in the drawing of her brother Michael and the family dog, "Mike (7) and Tippy" (p. 118). In her early years she had an unusually strong attachment to stuffed animals, which would later extend to real ones, as she rescued countless strays and cared for them. She literally spoke for the family dog, making his comments in a high voice.

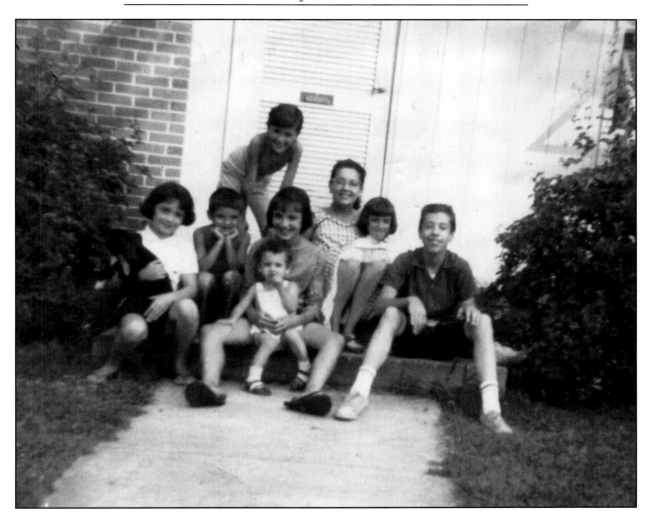

KAREN (HOLDING DOG) WITH MOM, SIBLINGS, AND UNCLE
1962, Charlotte, North Carolina

In 1962 the family moved to Charlotte, North Carolina, and life became easier. Karen's mother, Ethel, was much happier there, and life ran more smoothly for the family. Michael Carrino was born during the Charlotte period, and his role in Karen's life, and hers in his life, were to be vital—beyond that of parent and child or brother and sister.

At Michael's birth her mother jokingly said to Karen, "This one's for you." Karen took over her brother's care for the rest of their lives, allowing him to show his feelings as others in the family were not permitted to do, feeding him, washing him, taking him to school, cutting his hair, and watching over his health. Michael died with Karen on that terrible night; the many drawings Karen made of him reveal her devotion (see pp. 110–12, 114–19). They show him, movingly, asleep sprawled on his bed and dressed in the clothes she had bought and cared for.

> *Once Karen cut Michael's hair, had him put on a special sweater and took his picture. I was pretty hurt and went into my room, then Karen knocked on the door. I was crying, and I told her, "You show all this affection to him. What about me?" She washed my hair, gave me a haircut, had me put on my nicest sweater and took a picture of me, and she told me I'd always be special.*
>
> *She was great—she could throw a football; she didn't back down to any guy. I really admired that.*
>
> —Robert Carrino, Karen's brother

Years later, when Deborah was contemplating therapy, Karen remarked that Michael had done for her what therapy does for others. Deborah later felt that she meant he helped to keep her heart open and give her a function, a reason to live.

When the family moved back to Weehawken, New Jersey, much against Ethel's wishes, Karen had her own room and set up her own structured environment in the midst of the

KAREN AND MICHAEL
1971, West New York, New Jersey

chaotic life of the family. At thirteen years old, she cared for Michael even more than before, drawing him into her share of health and order, setting aside two drawers in her bureau for him, keeping their clothes laundered and ironed. She had begun baby-sitting around this time, taking Michael along, and she used the money she made to buy clothes for both of them.

> *She wasn't much of a TV watcher, nor did she go out and play much after school as the rest of us did. She'd come home and put on her Beatles records, clean her room, sketch, do laundry, etc. She led a very disciplined, organized life at the age of thirteen.*
>
> —Deborah Carrino

Karen's artistic life had begun during the summer of her thirteenth year, 1966, while Deborah and the oldest of her sisters, Irene, were away visiting an aunt. When they returned, they were astounded by the depth and technical ability shown even in Karen's very early work, like "Back View of Toddler" (p. 50). Karen's attitude toward her art was detached and professional; she looked for help and criticism in the family and from adult mentors.

> *I had been creating art since I was five years old, and Karen and I were always very close. When she was thirteen and I was fifteen I saw her drawing little heads. I advised her to copy photographs. I went away for the summer and when I came back I was very surprised. I said, "You've got it!" She really had the essence of the image. She would come to me and ask questions about art. I showed her how to draw the rounding of the nose and lips, the anatomy of the eye. Finally, she drew a boy in football uniform for my father [p. 102], and asked me what was wrong with it. I told her I could see nothing wrong with it at all.*
>
> —Irene Carrino

She was very good at both inner and outer contour. Most young artists initially do outline rather than contour. She's got both line and shape going; that's very unusual. And her tonal rendering is approaching spontaneity at an early age.
—Sarah Henry, Art Historian, Drew University

Karen began to articulate her ideas about child rearing at this time—at the age of thirteen she started baby-sitting a little boy named Charles, shown in her drawing on page 55. On her own, she formulated principles very similar to those of Summerhill, the revolutionary English school that granted children unprecedented freedom, without knowing of its existence. She wrote a letter to little Charles, which he would never read—an outpouring of pain and frustration as a happy baby became an angry child.

To Charles

My beautiful lost Charles

I have a little 6 yr old friend named Charles.
What can I do to help him?
I can't remove all the years of torment that he's been through.

He was a beautiful baby destroyed by the fangs of the monster, *the parents and*
 grandparents.
Charles, what can I do to save you?
I've been asked by a few "what makes you go so wild when you hear my name?"
I tell them that all I do is accept you for you, *not for* Chuck
because you're not Chuck at all.

I don't want to change you.

They have taken your beautiful blonde curls of your babyhood and watered them down and pushed them back just as they have watered down and slicked back your beautiful cookey personality.

You have become a loud unreachable little rebellious person because they have repressed your feelings and actions.

"Make him say 'please'." "Make him say 'thank you'." "Don't put that on my furniture." "If you curse you know what happens."

I won't say "Shame, Charles." when you're naked as they tell you I will, so don't go hide your delicate body behind your clean Hanes underwear. I used to change your goddamned diapers or have you changed over the passed 3 yrs? Don't be so stiff when I hold you in my arms! I only hope that when you grow up by some fuckin' miracle that you find your way because you could have been a fantastic little person. But I'm afraid I'll lose you to a more rebellious group who won't care about others feelings and what could I expect because of what's been done to you.

I want you to know that no matter what happens I will always love you for you, and also what I knew you as.

Love,

Ka

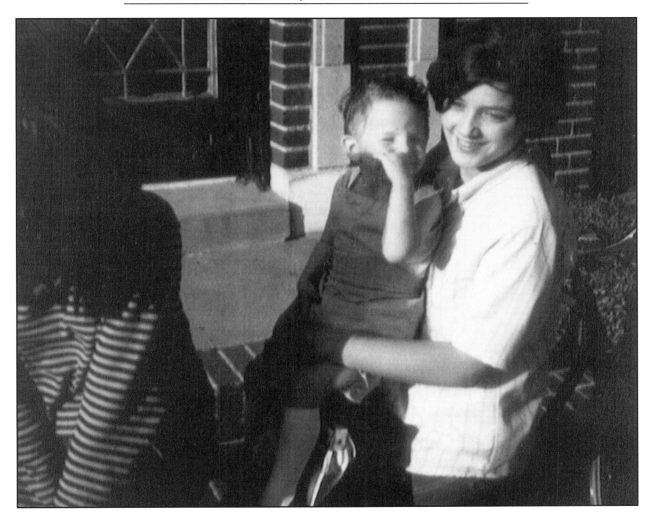

KAREN AND CHARLES
1968, North Bergen, New Jersey

She was strongly averse to the conditioning she saw foisted on children and women. She refused the prissy dresses and makeup, the alteration of natural appearance. Once Charles's mother told Deborah, then thirteen, "You need to start plucking your eyebrows." Karen vehemently replied, "No, she doesn't!"

At about this time, there was much conflict in the family. Karen's father was away from home a great deal, because of both his work and his love of bowling, and amid the turmoil they received mixed messages. One of these concerned Ethel's dedication to her religion, which she wanted the children to share. Their father told the children they could choose for themselves at thirteen whether to continue to go with her, and Irene, the eldest, made her choice. When Karen's turn came, she refused to go. Her mother tried to pull her along, but she sat on the staircase and held onto the banister; she cried for the pain of the situation, but stood her ground.

It was during this period that I could hear Karen crying late at night in her room. I think she felt very alone. I believe Karen was responding to the misery in the family. I feel that she learned how to be alone at this time.

—Deborah Carrino

She made up poems and songs to her animals and her siblings, protected those she loved against injustice, stopped to entreat people in the street from abusing children; but she was also endearingly a teenager who produced pictures of the Beatles, of television personalities from *Mod Squad*, of Jerry Lewis, Davy Jones of the Monkees, of national figures like the Kennedys and, inevitably, their children. Karen's great hero was John Lennon, and Deborah later found a petition she had organized to keep him from being deported by the U.S. government. Her devotion is shown in images like those on pages 142–47. Lennon and the other adults Karen used as subject matter were unmasked, like the children, in their roles as

JOHN LENNON (WITH SHOPPING BAG)
May 20, 1970. Graphite, 5″ × 9″.
Courtesy of Barbara Carrino

communicators; they revealed themselves through their art and beliefs as people who were company for her in her principles and ideas.

> *She played Beatles music relentlessly—I have her albums and they're so worn, you can no longer play them.*
>
> —Deborah Carrino

She loved practical jokes and, with a friend, would go to the entrance of an amusement park during summers on the Jersey shore and place an egg on the ground where people would walk after leaving a ride. Then she and the friend would shout, "Don't step on the egg!" and gleefully watch people tie themselves into knots avoiding the egg, which was sometimes not there at all. She was a person, not a saint. She had a strong tomboy period, pioneered blue jeans at school, and, like many independent girls, she went through a phase of wanting to be a boy: cutting her hair short, wearing boys' clothes—there's an irresistible comparison to Jo in *Little Women*.

Her acute perceptions sometimes turned to humorous remarks about the foibles of those around her.

> *She loved to tease and laugh at people. She would say something about you, and you'd want to strangle her, but you couldn't because you'd be laughing too hard.*
>
> —Deborah Carrino

During the spring of 1969, Karen and Irene became suspicious of their father's relationship with a woman who worked at a bowling alley where the children took part in a weekly junior bowling league. When they confronted him, he admitted that he was involved with her, and asked that they keep the truth to themselves.

After living with the secret or a while, Karen could no longer bear it. Knowing full well the consequences of her actions but feeling that it was the only right thing to do, she told our mother. Of course, there was a major blow-up, and after that everything fell apart. For a long time afterward, Karen would express feelings of guilt to our father, even though he tried to reassure her that it was all right. It must have been a very difficult decision for her to make at that age.

—Deborah Carrino

Her parents separated in 1969, when Karen was fifteen, and later divorced. Irene, Deborah, and Barbara went to live with their father. Karen stayed with her mother, for Michael's sake, along with the other young children. For a few months, the two groups of children were divided.

She begged us to come back home, but we just couldn't. I remember the first time we saw her after that, she hugged us so tightly and cried.

—Deborah Carrino

During the next three years all the children met weekly at their father's house. Karen would come with her sketchpad, Michael, and Tippy, the dog.

She was very perceptive. When I was quite young I had taken a fall, and we came home late. I was very dizzy. The next morning I was vomiting. Karen was home with me and she said, "Mommy didn't realize you could have a head injury." She called my father, since my mother wasn't home at the time, and he came and brought us to the hospital. She was very mature. I remember, too, that whatever she felt needed to be done, she wouldn't rest until she did it. She had

the wherewithal to act on her conscience, whether it was confronting people about their treatment of animals or children or helping someone who needed it.
— Joan Carrino, Karen's sister

Karen's work was handed out in all directions. She gave her art freely to people who fell in love with it. She re-created some of her best pieces more than once, because she had given away the first version and wanted another to keep (see p. 155).

Her work also went into others' homes when it was sold one summer on the Jersey shore. Her mother was short of money and the added cash helped to feed the family.

She gave the drawings she regarded unsuccessful to Michael to color (see "Made-up Boy," p. 54).

Her gifts are shown increasingly in every piece as she grew more accomplished and confident in her technique.

Karen didn't believe in talent. "If you can see well, you can draw well," she said. And in her case this may well be true, because her portraits are the result of her inner vision, her empathy (see p. 85).

She had a gift for rhythmic line ... innate spatial and visual ability. She had a remarkable sense of an integrated, fluid rhythm that sets up connections, especially among the pieces drawn directly from a model. In her work there are fluent interrelations that deepen the quality of empathy—that's how it was effected.
— Michael Peglau

She never shirked the responsibility empathy brings: to speak for those who cannot speak for themselves. Karen chose children for her art as she chose them for her life, because they are unguarded and genuine, without masks, as in "Girl with Daisies" (p. 109).

They're so natural. I'd much rather draw them than adults—the young ones aren't trying to hide anything.

—Karen Carrino, interview in the *Jersey Journal*, February 22, 1972

She went to Memorial High School for her last two years. There she found stimulation, recognition, and help from the teachers. She created a prize-winning poster of a child on crutches for the Elks Club in 1970, at the age of sixteen. During this period she sketched and painted all the time, handing many of her works to friends and relatives.

Karen would later refuse a scholarship to Boston University, which was a disappointment to her art teachers. She felt it was too far away from Michael, and that he was too young for her to go. Her teachers said she had the opportunity to go to Harvard or Yale, too, but Karen was adamant that this was not the time.

She didn't understand why I was so angry that she didn't want to go to school. . . . She was so fresh. When I got mad at her about turning down the scholarship to Boston University, she told me that another of her teachers told her that one could get a master's and a Ph.D. in art and that since I didn't have those degrees, I couldn't yell at her. She said, "You're not finished yet." She was such an inspiration—she was the reason I went back to school. . . . She was so spirited and she seemed to open roads for people. She knew her mission.

—Adrian Groves, one of Karen's art teachers

She sketched everywhere—at the kitchen table, at the laundromat, and, as I found out from her teachers, in class.

—Deborah Carrino

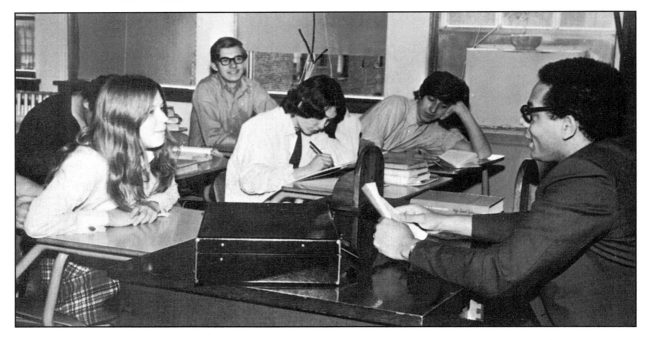

KAREN SKETCHING IN STUDY HALL, MEMORIAL HIGH SCHOOL
1971, Memorial High School Yearbook, West New York, New Jersey

Before she was in my class, she only drew from photographs. I got her to draw from life. She did this drawing of Gail Robinson in class, and I wanted to buy it from her. She had a royal fit about accepting money. I wanted to pay her $100, but she wouldn't accept it—I should have just bought her that much in art supplies. I gave the drawing to one of my teachers a few years later at Montclair State College. It is still there.

—Adrian Groves

As a high school student, she had no inhibitions about drawing the children of her art teacher or sharing her art with adults from all walks of life. When Deborah photographed some of Karen's work belonging to Judge John J. Grossi Jr., she found to her surprise that although he was her father's acquaintance, he had been Karen's friend first, a relationship that began during the period when the children were separated. He had been so impressed by Karen's clarity and compassion that they became great friends.

> *I met her at sixteen, and she was very mature at that point. It's been a long time now, but I remember that child as though it was yesterday. She was a person without enmity and without guile. She concentrated on the joy of living; she didn't waste time on hostility. It must have been her art and the fact that she was able to create such beautiful things that sustained her.*
>
> *She had a fierce desire to put on paper the beauty of children. She used to come to my office, just show up with a big portfolio and Michael in tow. I always made time for her, and encouraged her in her education as well as her art.*
>
> *The love of a child, her art, and her devotion to that art gave her a very rich life—more than most people.*
>
> —John J. Grossi Jr.

When the driver of the car that killed Karen, Michael, and Lisa was found, John Grossi was the family's lawyer.

At seventeen Karen discovered the revolutionary English school Summerhill and A. S. Neill, who published eloquent books on its principles of education. She had found company: educators whose views coincided with her own. She declared her ambition to be a part of such a school and help liberate children from the stultifying and rigid schools she knew. She found another ally at this time when she started baby-sitting for Sian Lieb, pictured on

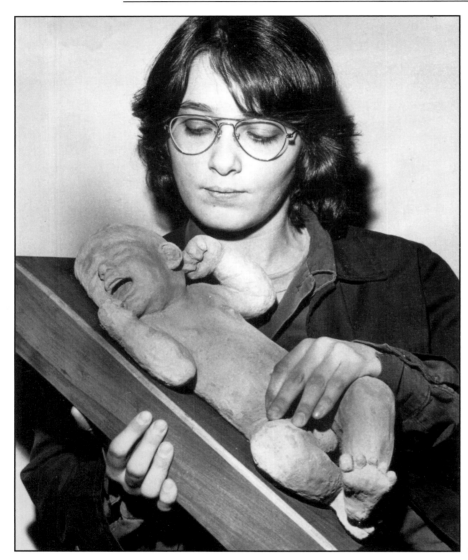

**KAREN WITH
SCULPTURE
"BABY JULIAN"**
*February 1972,
Jersey Journal*

page 133. She felt she was finally working with a child who had a healthy relationship with her mother, a mother who just let the child be herself without trying to mold or repress her in any way. Sian's mother, Molly, felt drawn to Karen immediately.

> *She came home so excited after that first day of baby-sitting for Sian and told me "Here's a kid who knows what she wants and just says it, and her mother lets her express herself, and she doesn't shame her about being naked."*
>
> —Deborah Carrino

The photograph on page 34, taken during an interview by the *Jersey Journal* at a school show in 1972, clearly indicates Karen's outrage when the photographer insisted that her hand cover the genitals of her clay infant; she was similarly outraged when parents scolded their children for not being fully dressed. In a way, it's amazing that her children of art had such strong acceptance, since there is nothing sugary or idealized, just the truth. Her fundamental knowledge that children are not clay to be shaped, but complete individuals is clear in her art, and her desire to work at a school modeled along the lines of England's Summerhill was passionate.

In the *Jersey Journal* article the reporter brought out Karen's convictions about children and education: " 'I want to free children,' said Karen, explaining that she wants to work with them in a relaxed educational situation. She feels that the traditional school set-up is confining—she says she can start her own work at school, but can never finish it there."

Karen felt strongly that children should be allowed to make decisions early, particularly with regard to their appearance and their beliefs; she believed that, in general, parents were not treating their children with respect or allowing them to express their own ideas.

Karen's children are allowed to have emotions as she and her siblings were not, as her works on pages 112, 121, and 128 show. She made sure that Michael, who was her child in

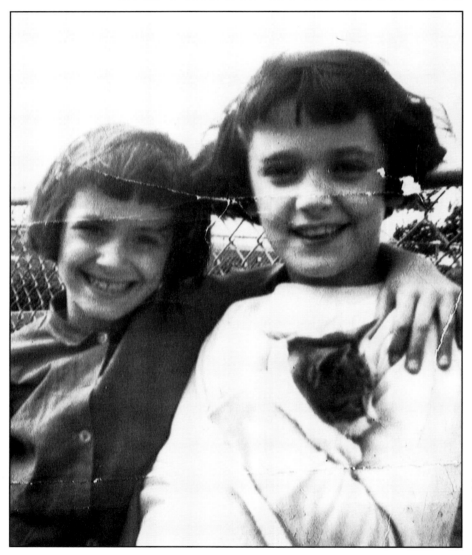

**KAREN AND DEBORAH
WITH TIPPY-TOP**
*1962, Union City,
New Jersey*

all but birth, was able to express his feelings. In her art the children are angry, scornful, introspective, happy, stubborn. The same child appears at different ages, the changing moods clearly recorded with the physical growth. The youngsters she saw and captured on paper and canvas are mingled with children drawn from her imagination, including her sketch of Deborah's imaginary future child ("Deb's Son," p. 54).

Deborah and Karen were so close in age that they attended school in the same classes. Now Deborah is twenty-eight years older and Karen will always remain nineteen. Deborah comments, "People used to ask if we were twins, and Karen would always correct them. She wanted to be herself, an individual." In many ways, their photographs show that they were very different: Deborah quicksilver and radiant, Karen always strongly centered while totally aware and responding to what was around her.

At eighteen Karen came with Michael to live at her father's home. During this last year she blossomed; she was full of plans to adopt children, to go on with her art, to teach.

We were very close before; then we were becoming reacquainted as adults.
—Deborah Carrino

Karen got a Volkswagen Bug, an instrument of freedom at the time when she began to spread her wings. She would pick up family members and take them for rides, on picnics and pleasure trips. Just after the fatal automobile accident, Deborah's last thought as she was taken from the scene was that Karen was going to be so distressed that the car had been destroyed.

She had her first real boyfriend, Steve Miller, a Vietnam veteran who valued her for herself and her ideas. Her drawing on page 38 shows her warm affection for him.

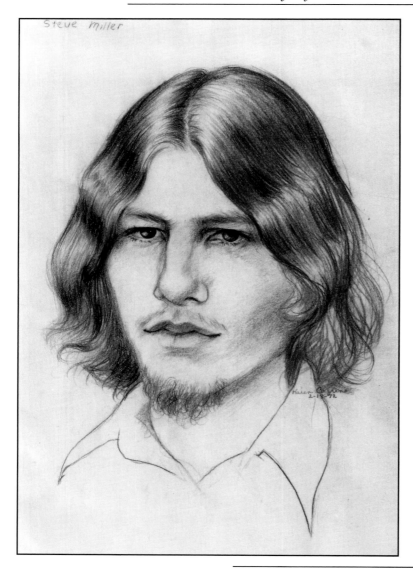

STEVE MILLER
February 18, 1972.
Graphite, 14" × 17".
Courtesy of Steve Miller.

They were always hugging and kissing, but more innocent and loving than sexual.

—Deborah Carrino

The circumstances of her death are bizarre, almost fateful. A few days after her nineteenth birthday, someone slashed a tire on Karen's beloved Bug; had it not happened, none of the rest would have occurred. She hadn't had time to have the tire, now her spare, repaired before the birthday party on December 9, 1972. Molly Lieb, Sian's mother, had arranged the party for Karen, and she wanted her family to see the charming mural she had painted on Sian's wall. Knowing how cramped the interior of the Bug would be, her father urged Michael to ride home with him after the party, but the boy wanted to ride with Karen. In addition, Deborah, Steve Miller, three-year-old Lisa Boudrie, her one-year-old sister, Teresa, and Karen's friend Liliane Holding were all in the car.

While she was returning home on the Garden State Parkway, one of her tires went flat. The police arrived and called for a tow truck, which took Steve to a gas station to get the tire repaired. Karen's tire proved to be beyond repair, and Steve telephoned Molly, who also had a Volkswagen. She sent a friend to them with a tire, but the rim size was wrong for Karen's car. Again, Steve went to the gas station, this time to put Molly's tire on Karen's rim.

Karen had pulled the car as far off the shoulder as she could—so far that I feared we would slip into the gully between the shoulder and the embankment. I think she realized the danger we were in, and she wanted to protect us. In fact, before help arrived Steve had been walking around on the shoulder of the road and Karen pleaded with him not to. Down to the last moments of her life she was so present and concerned for everyone around her."

—Deborah Carrino

During the long wait, the children became fretful, and Karen brought them back to good spirits by reminding them that Christmas was coming; after a while they slept, Teresa in Karen's arms. Karen and Deborah talked quietly; they noticed that the police emergency vehicle had left. Karen dozed off, while Deborah remained awake.

An explosion on the driver's side was all the first indication Deborah had that a car had rammed into the parked vehicle. The car drove away, speeding on just its tire rims. Deborah spat out glass (she thought it was her teeth) picked up Teresa, who had slipped under the dashboard, and tried to resuscitate her sister, but she was afraid to do much for fear of making things worse. An ambulance came, taking Lisa and Michael to the hospital. Neither child survived.

Karen, picked up with the others in the second ambulance, died in the hospital. Deborah and Teresa and had only minor injuries; Liliane had a concussion from which she recovered completely.

Among the thousands of questions about that night, Deborah wonders how a driver could hit the infinitesimally tiny target that was their small car, pulled well off the road? Why were no flares set when the police were at the scene? Would Karen have lived if she had been taken to the hospital in the first ambulance?

Karen, Michael, and Lisa share a single grave in Weehawken.

Fate had it that she and Michael went together. Neither of them could have lived without the other.

—Steve Miller, Karen's boyfriend

The driver of the car was apprehended later; he was on parole and had been drinking. He pleaded guilty to two counts of manslaughter and was incarcerated.

I went by myself to the trial in Newark. I had to see who would do this. He was just a young guy. I needed to hear "I'm sorry." What he said was, "It must be so hard for the families of the victims." Later, I realized that was an apology.

—Ethel Carrino

❦ ❦ ❦

At the time of her death, Karen was excited about her dreams of working for the Fifteenth Street School in Manhattan, where many ideas similar to hers were being used. Her art is an overflow, the fruit of her love and understanding for children, the open, undefended innocents she preferred to adults. She wasn't so much an artist who concentrated on children as a penetrating lover of children whose feelings manifested in various ways: service, fun, and some wonderful art that allows others to share her ability to see the essence of each child, not just the essence of childhood. A single eye and nose, a folded arm (see pp. 86, 87), and the essential nature of the person living in the child's body comes through. Karen hoped to have a large family and to adopt children from different ethnic backgrounds.

She demonstrated her love with pen, pencil, pastels, watercolors, oils, and finally in clay. Her subjects came from photographs of children she knew and children she had never met in the flesh, from life and from her imagination. Usually, art derived from photography is a surface matter, but in her case the photographs seem to have been a door to an inner portrait (see p. 146). Not surprisingly, she enjoyed the work of Mary Cassatt and Norman Rockwell.

She had so much potential. Her empathy with her subjects was far greater than most, and she had a wonderful feel with her line; she could inhabit that line. Most kids that age are fixed on rendering what things look like. Here you have a dialogue with the subject—there's exploration, dialogue, and connection.

—Sarah Henry

Karen's death must be counted a tremendous loss to so many who never knew her, as well as to her family and friends. It isn't hard to imagine all the things she would have done and created, were she alive today. However, she lived her short life fully, leaving a legacy not only of love, but of the action that manifests love. Her courage, her compassion, and her vision all live on in her work and in the memories of those who were fortunate enough to feel the effect of her spirit and understanding.

This book is something that should have happened, whether I did it or a stranger did it. In other words, I didn't do it to heal myself, as some people want to believe—although some aspects of this journey have been healing, it's also been difficult and painful. But it feels like in some way I'm doing right by Karen. I'm just a messenger.

My hope is that people will be able to view the work and not have the beauty of it be overshadowed by the tragedy. Although I think for my family as well as myself it's sometimes hard to look at it without the pain clouding our vision, I still find Karen's work to be inspiring. As an artist, she inspired me to find in myself what I truly love to paint and draw—the earth. As a person, she inspired me to listen to my heart. My hope is that Karen's vision comes through to artists and educators, students and parents, to extend her influence past her life.

—Deborah Carrino

THE ART OF KAREN CARRINO

INDEX OF ILLUSTRATIONS

Titles given by Karen are in bold.
Titles given by Deborah are in italics.
Karen's remarks on her work are indicated by brackets.
Sources have been given for works based on published photographs or other images
where they could be determined.

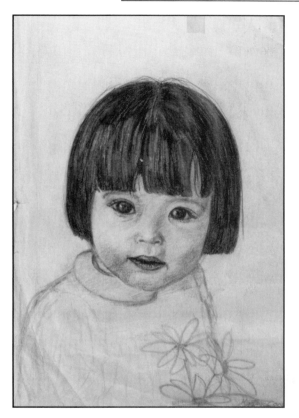

GIRL WITH FLOWERS
December 17, 1967. Graphite, 9" × 12".
Courtesy of Barbara Carrino

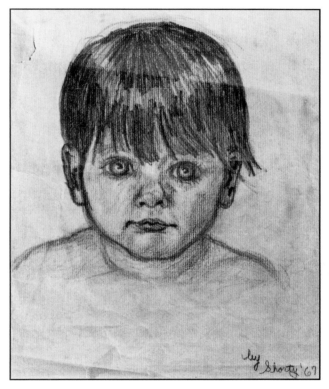

BLUE-EYED BOY
1967. Graphite, 9½" × 12½".
Courtesy of Deborah Carrino

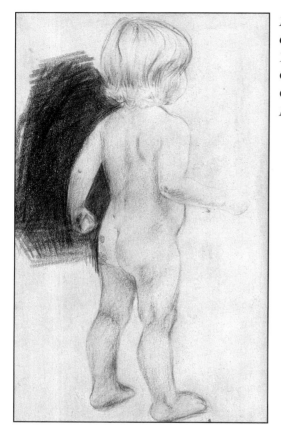

**BACK VIEW
OF TODDLER**
*No date.
Color pencil, 5" × 8".
Courtesy of
Martin Bendian*

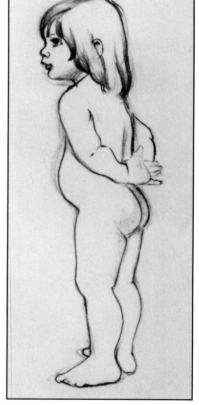

**SIDE VIEW OF BOY,
MADE-UP**
*No date.
Graphite, 7½" × 10".
Courtesy of Georgette Presto*

Karen and I were in home economics class together. We had a good time because we both hated that class. She gave me this drawing in class and said, "Here, I did this for you." I stuck it in my sketchbook. I found it years later after I was married. Karen would occasionally come up to the park to hang with us and she'd bring Michael with her. She was always sketching and I don't think she heard a thing the teachers said. —Georgette Presto, classmate

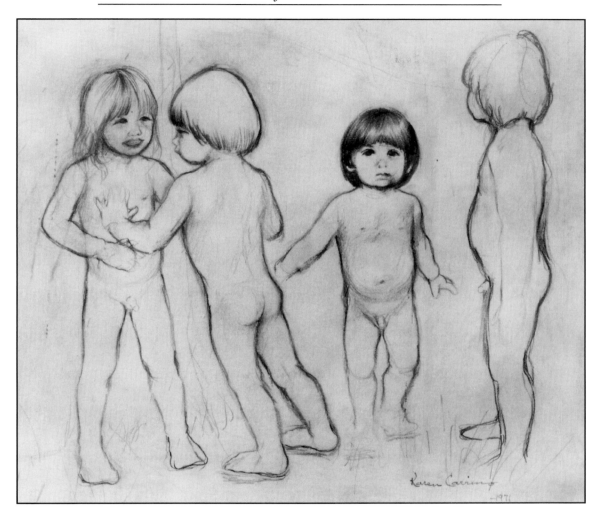

MADE-UP GROUP OF BOYS
1971. Graphite, 11" × 9½". Courtesy of Irene Carrino

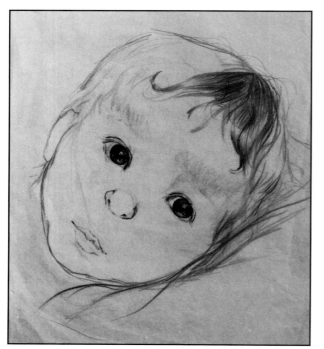

BABY LYING ON BLANKET
No date. Graphite, 12" × 18".
Courtesy of Barbara Carrino

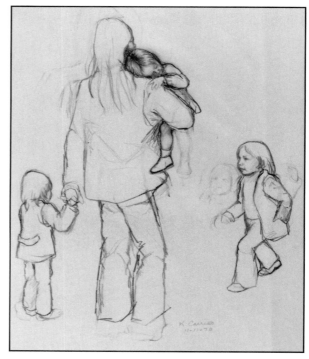

MAN WITH CHILDREN
November 11, 1970. Graphite, 9" × 11".
Courtesy of Ethel Carrino

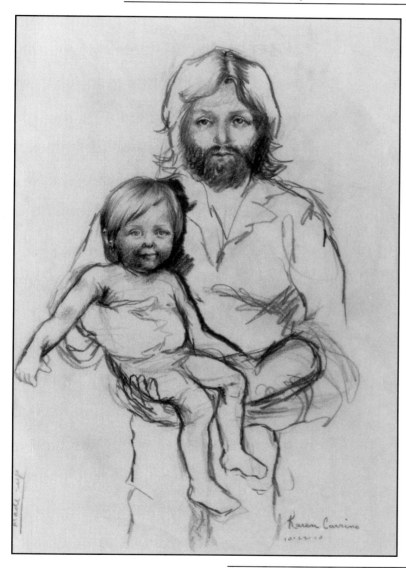

MAN HOLDING BOY
October 22, 1970.
Graphite, 9½″ × 13½″.
Courtesy of Barbara Carrino

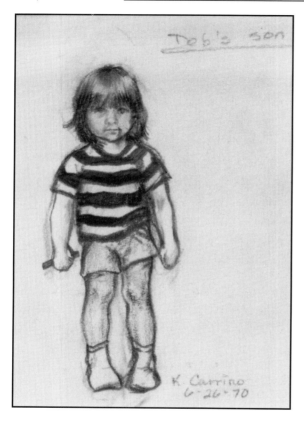

DEB'S SON
June 26, 1970. Graphite, 6½" × 12".
Courtesy of Deborah Carrino

MADE-UP BOY—
COLLABORATION WITH MICHAEL
December 1967. Graphite and crayon,
8½" × 13½". Courtesy of Ethel Carrino

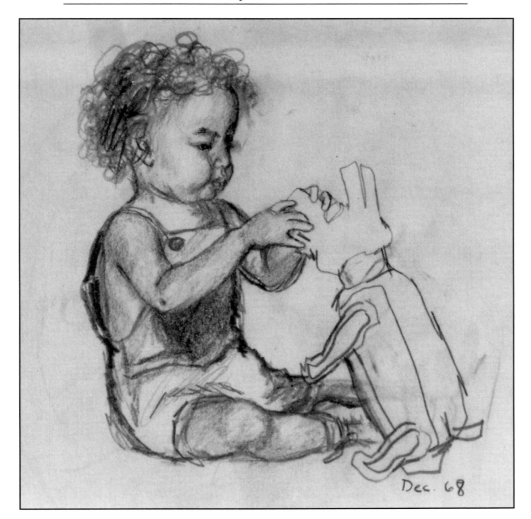

CHARLES WITH TOY
December 1968. Graphite, 7" × 7". Courtesy of Ethel Carrino

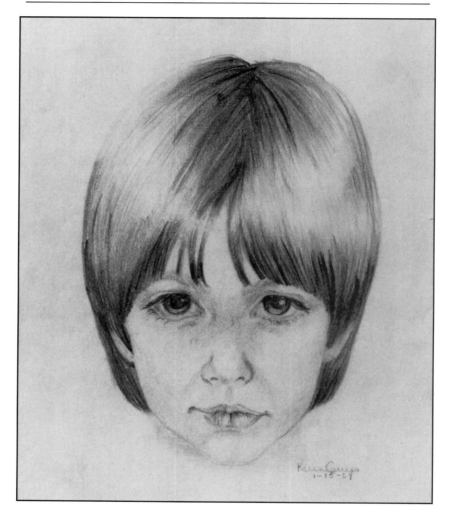

MADE-UP BOY—SAD EXPRESSION
January 15, 1969. Graphite, 9" × 11". Courtesy of Barbara Carrino

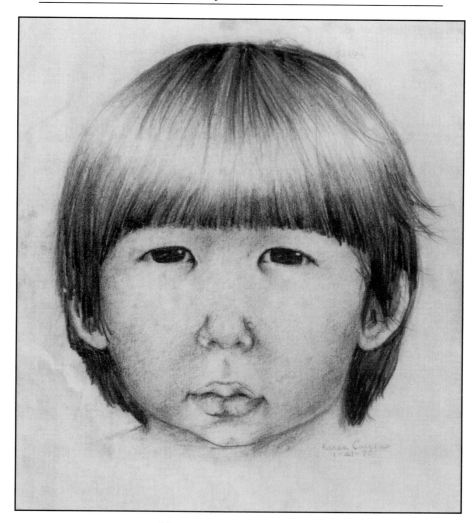

MADE-UP JAPANESE BOY
January 21, 1970. Graphite, 10" × 13". Courtesy of Irene Carrino

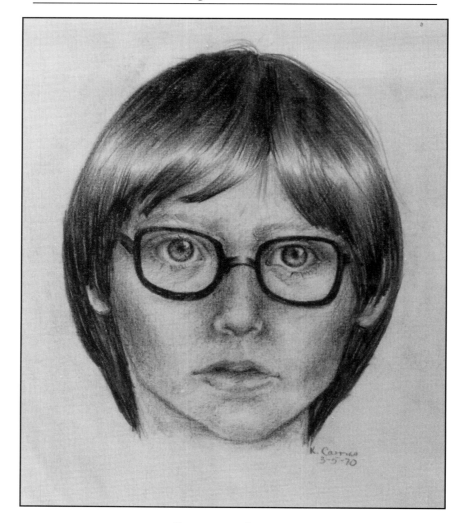

BOY WITH GLASSES
March 5, 1970. Graphite, 12" × 18". Courtesy of Deborah Carrino

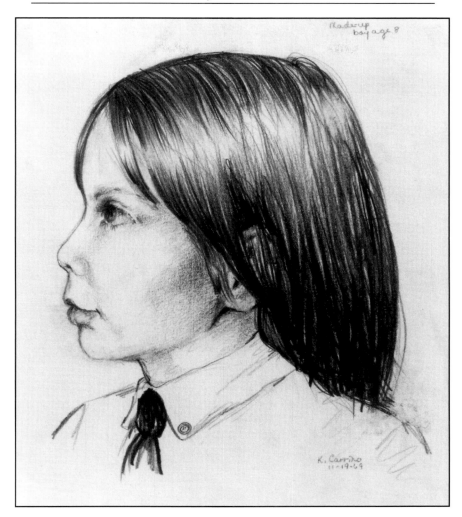

MADE-UP BOY—AGED 8 (WITH TIE)
November 19, 1969. Graphite, 9¹/₂" × 12". Courtesy of Deborah Carrino

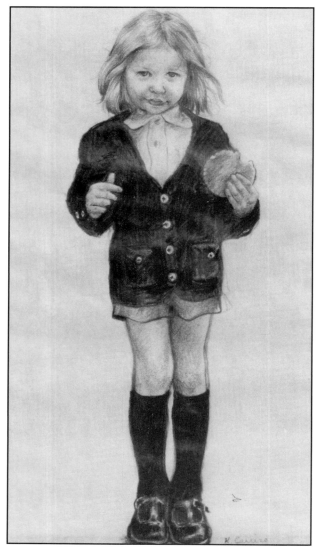

BOY WITH COOKIE
August 7, 1970. Graphite, 7½" × 13½".
Courtesy of Barbara Santillo

[To Barbara, one of the few who really care]

I don't remember how I got to know Karen—probably through Carol Pollen. I can see that hat and jacket. I was amazed at the brilliance of her work. We were all in awe of her genius. Michael sat in my class and colored while Karen went to class. I gave him cookies. Karen asked me if it was OK that Michael sit in my class and I said, "Of course." She asked me if I wanted her to do a drawing of me and I said no, that I would like one of Michael instead. She gave me this drawing of a little boy eating a cookie which I thought was Michael.
—Barbara Santillo, teacher

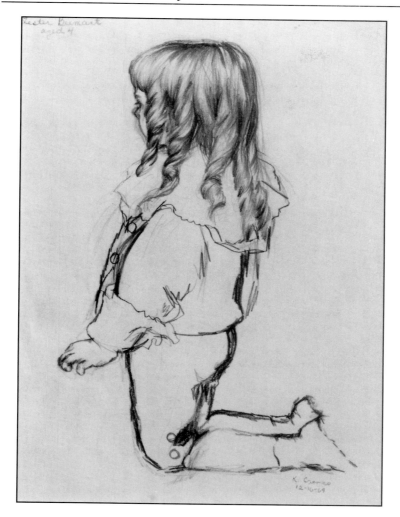

LESTER BUMONT, AGED 4
December 16, 1969. Graphite, 10½" × 14". Courtesy of Ethel Carrino

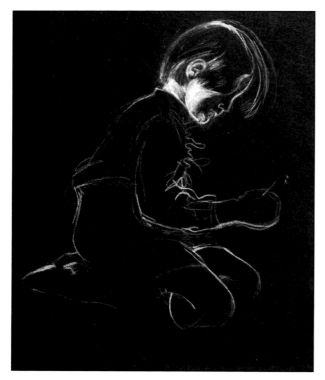

BOY IN GRASS #2
No date. White pencil on black paper,
8$\frac{1}{2}$" × 9$\frac{1}{2}$". Courtesy of Robert Carrino

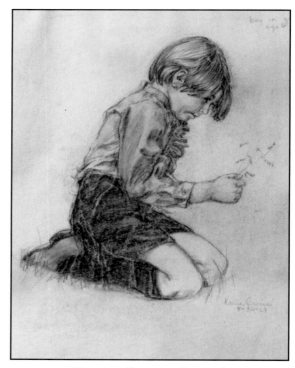

BOY IN GRASS—AGED 6
August 30, 1969. Graphite, 8$\frac{1}{2}$" × 10".
Courtesy of Joan Millspaugh

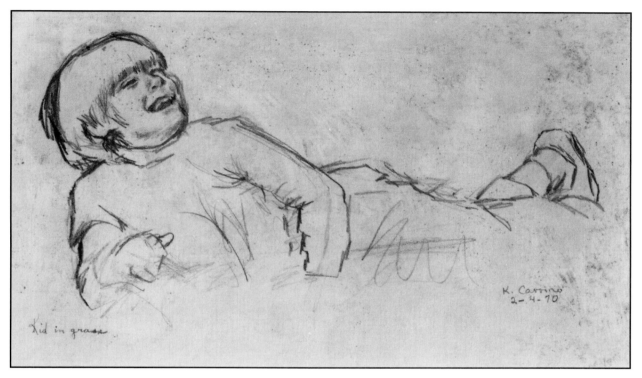

KID IN GRASS
February 4, 1970. Graphite, 12" × 7". Courtesy of Robert Wilson

She was in my history class in her full counterculture look. She would always be drawing but not at the expense of her work. She would chat with Frank Cocuzza and myself after school. I bought two pieces at the exhibit and I gave one to my sister. —Robert J. Wilson, teacher

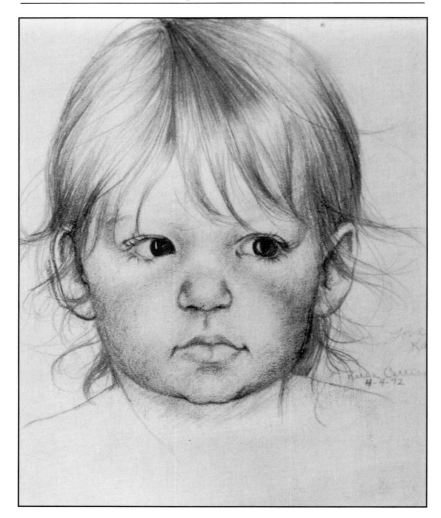

LITTLE GIRL—LOOKING TO LEFT

April 4, 1972. Graphite, 7½" × 9½". Courtesy of Molly Feuer [To Molly, Love Ka]

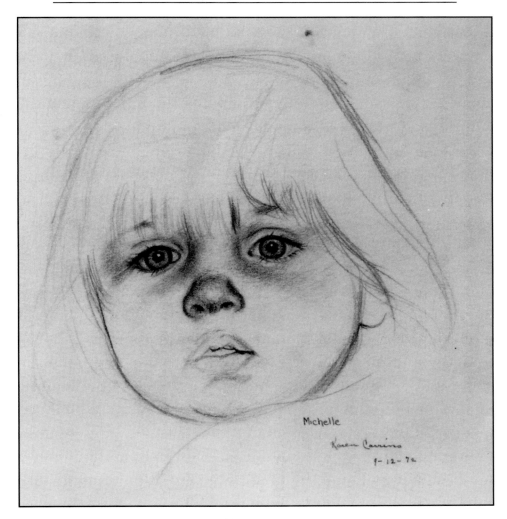

MICHELLE
September 12, 1972. Graphite, 9½" × 10½". Courtesy of Barbara Carrino

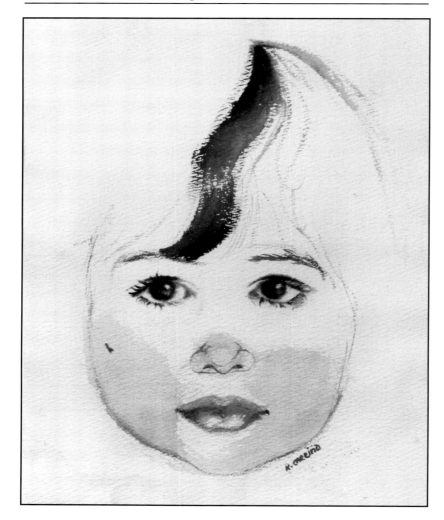

GIRL'S FACE
No date. Watercolor, 8" × 10". Courtesy of Barbara Carrino. A gift from Marilyn Mavric

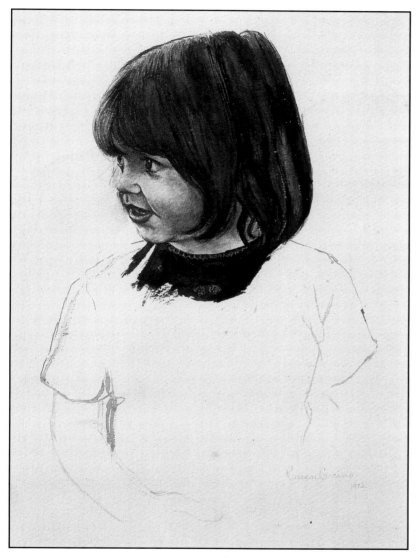

GIRL IN BLUE DRESS
1972, Watercolor, 11" × 15".
Courtesy of Allan DeFina

I had a crush on Karen. There was something about her that drew you to her. Perhaps it was because she was so spirited. I wanted to know her and I remember working on a glass-recycling project that she was involved in—just so that I could get to know her better. When Karen died, I felt cheated. Ms. Barbara Santillo, English teacher and Drama Club director, purchased one of Karen's paintings and gave it to me because she knew how much it meant to me. It still means a lot to me—especially because of the kindness and sensitivity Barbara Santillo showed in giving it to me. —Allan DeFina, classmate

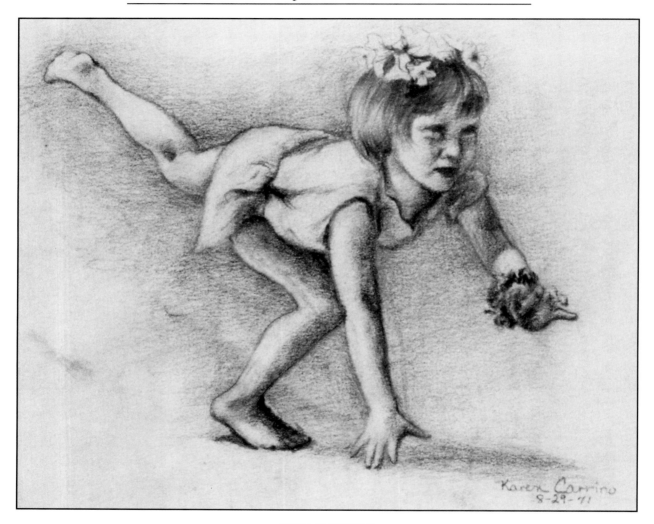

GIRL DANCING
August 29, 1971. Graphite, 8″ × 6″. Courtesy of Doris Yambra

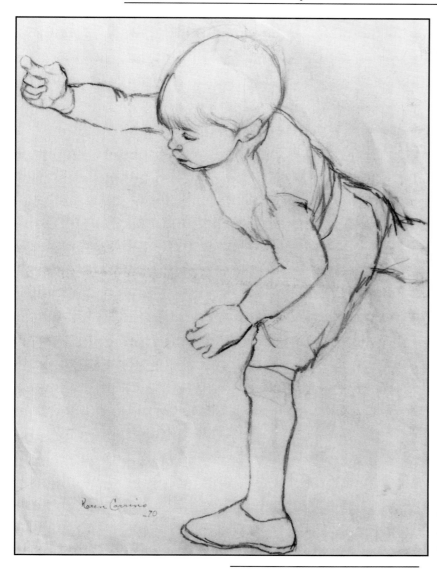

BOY BOWLING
1970. Graphite, 10″ × 13½″.
Courtesy of Irene Carrino

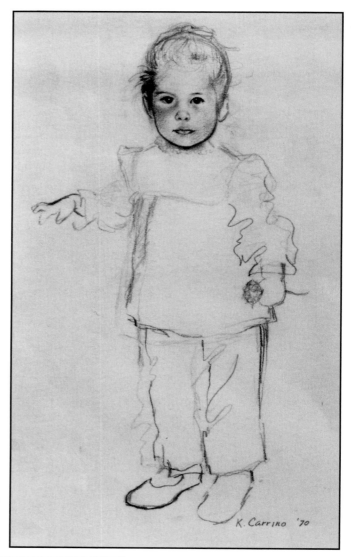

LITTLE GIRL—WITH HAND OUT
1970. Graphite, 14" × 17".
Courtesy of Barbara Carrino

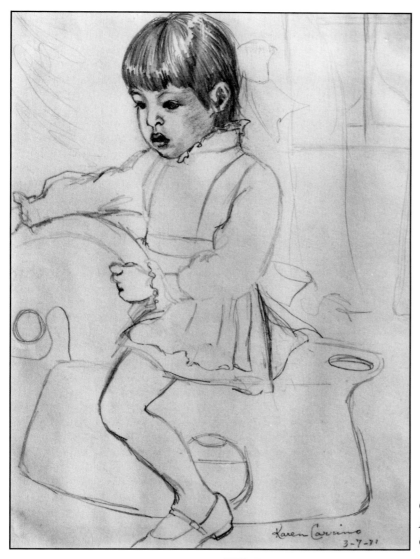

GIRL ON ROCKING HORSE
March 7, 1971. Graphite, 8" × 11".
Courtesy of Carolina Lega

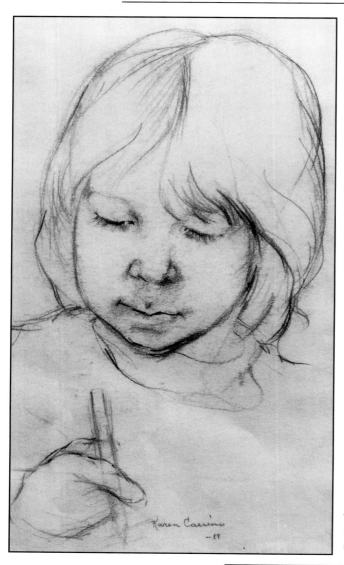

BOY WITH PENCIL
1969. Graphite, 10" × 14½".
Courtesy of Deborah Carrino

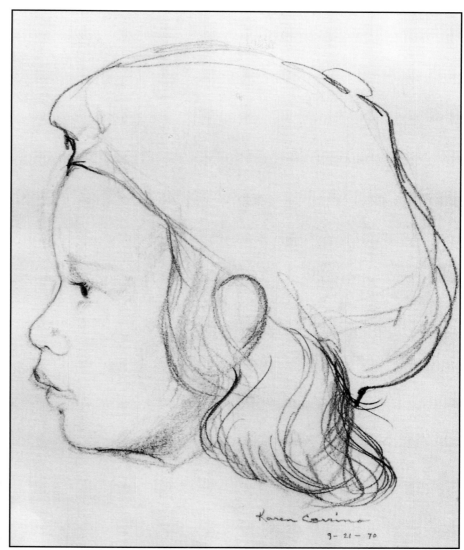

CHILD IN BERET,
MADE-UP
September 21, 1970.
Graphite, 9" × 10½".
Courtesy of Jim Wittes

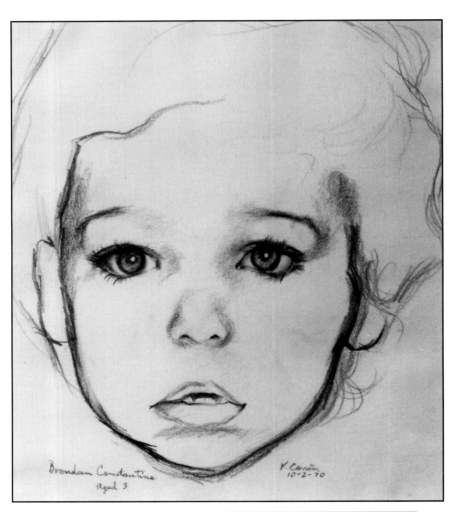

BRANDON CONSTANTINE
October 2, 1970.
Graphite, $9\frac{1}{2}'' \times 11''$.
Courtesy of Deborah Carrino.
A gift from the Zaccone family

"She has a great love for children and would sacrifice her art for them."
—Fabian Zaccone,
Karen's art teacher
(now deceased, quoted in the *Jersey Journal,*
February 1972)

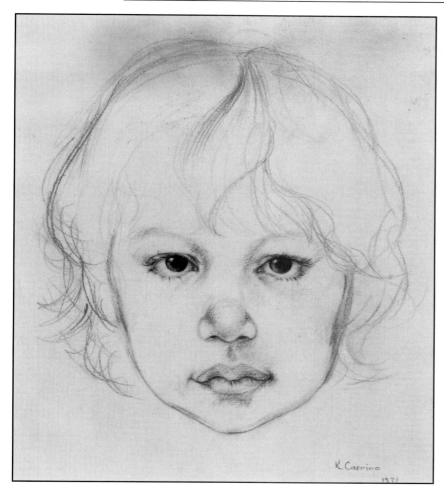

SERIOUS BOY—MADE-UP
1971. Graphite, 11″ × 12″.
Courtesy of Joe Calabria

The Karen Carrino artwork in my possession is treasured since the artist, who I met briefly on several occasions, departed this life before the normal order of things. One wonders what this fresh, prolific talent might have accomplished if given life's full measure. Her legacy is unique and priceless.
—Joseph M. Calabria

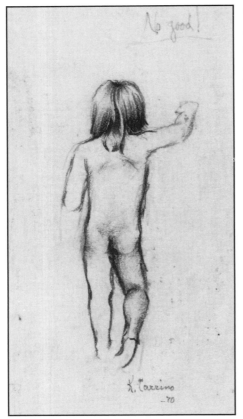

CHILD FROM REAR
1970, Graphite, 3½" × 7".
Courtesy of
Barbara Carrino
[No Good!]

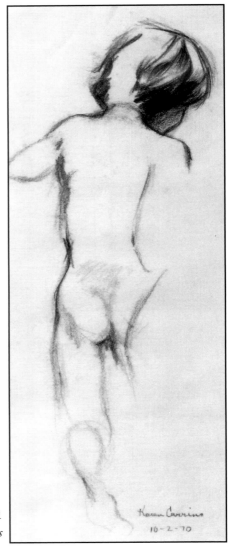

UNFINISHED BOY FROM REAR
October 2, 1970. Graphite, 11" × 4½". Courtesy of Fran Collins

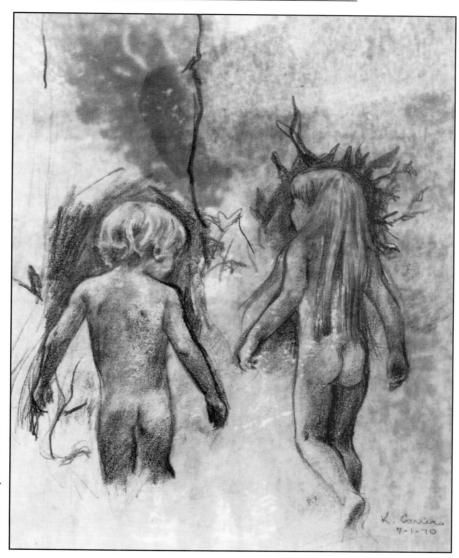

BROTHER AND SISTER
July 1, 1970.
Graphite, 8" × 10".
Courtesy of
Deborah Carrino.
A gift from Scotti and
Charles Mussara

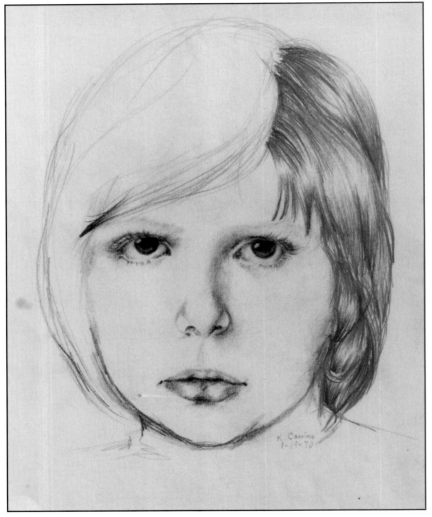

BOY'S FACE—
LOOKING UP
January 19, 1970.
Graphite, 11" × 14".
Courtesy of Cathy Miller-Keller

Karen and Steve had come over on Thanksgiving (1972). They had already eaten. Karen was holding my son Michael (then six months old). I looked over at one point and saw that Karen was letting him suck on a mint. I got upset, but Karen told me not to worry, that she wouldn't let it go. Michael spilled grape juice on my carpet that day. I could never get the stain out and after the accident (where they died), I couldn't throw out that bowl of mints for years.

—Cathy Miller-Keller

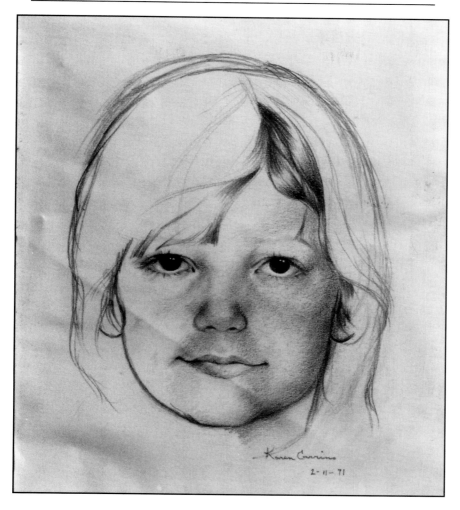

MADE-UP BOY—PLACID EXPRESSION
February 11, 1971. Graphite, 10" × 11½". Courtesy of Sister Carmela M. Cristiano, S.C.

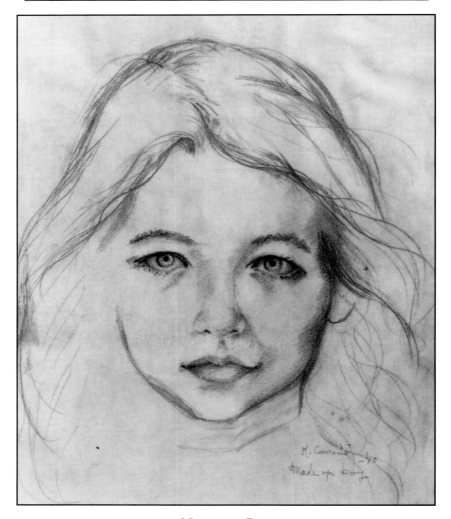

MADE-UP BOY
1970. Graphite, 10" × 12½". Courtesy of Robert Delaney

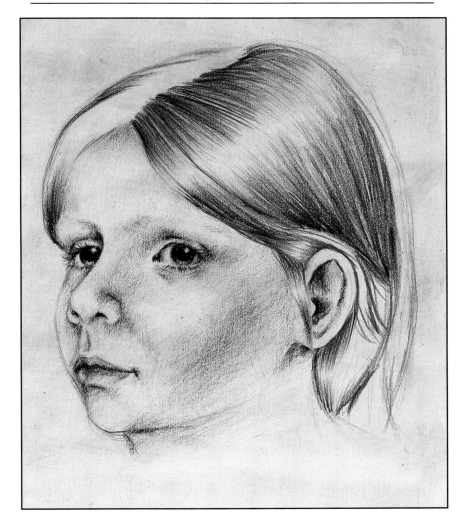

BOY WITH BLOND HAIR
No date. Color pencil, 10" × 12". Courtesy of Irene Carrino

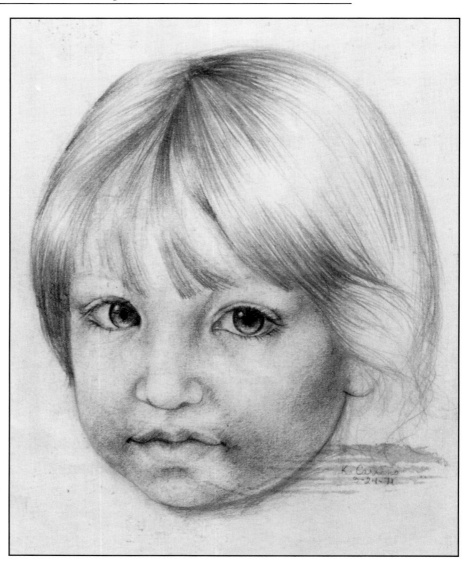

FAIR-HAIRED BOY
March 24, 1971.
Graphite, 7" × 9".
Courtesy of Irene Carrino

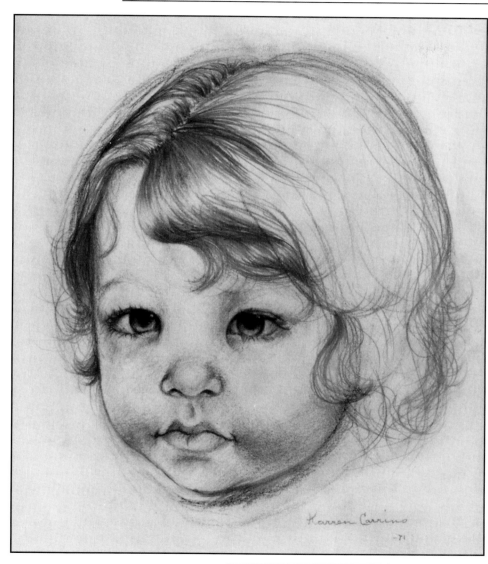

CHILD WITH CURLY HAIR
1971. Graphite, 8½" × 10½". Courtesy of Alina Garcia

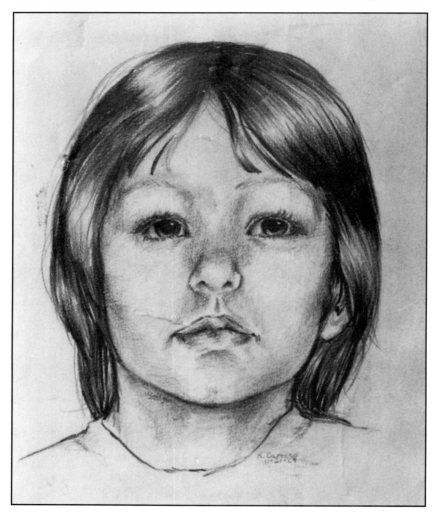

CHILD LOOKING UP
November 21, 1969. Graphite, 8″ × 10″. Courtesy of Barbara Carrino

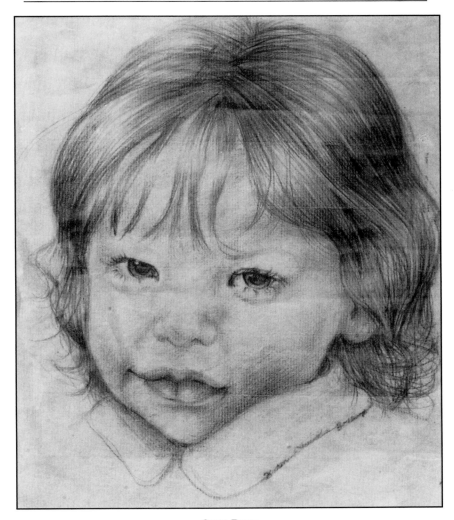

SHY BOY
March 15, 1971. Graphite, 7¹/₂″ × 9″. Courtesy of Barbara Carrino

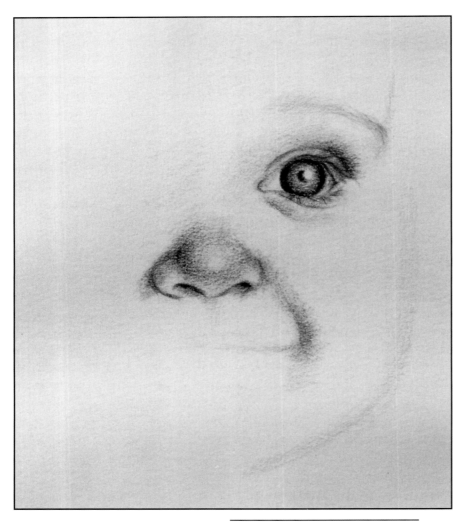

ESSENTIAL BABY SMILING
No date. Graphite, 7" × 7".
Courtesy of Ethel Carrino

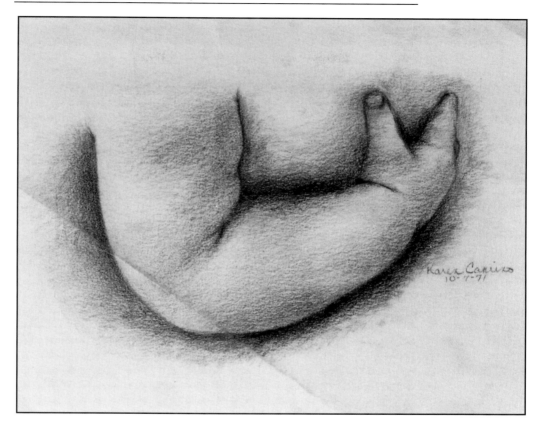

BABY'S ARM
October 7, 1971. Graphite, 8½″ × 6½″. Courtesy of Barbara Carrino

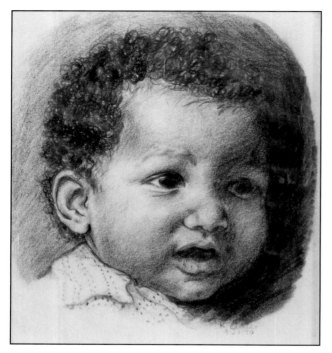

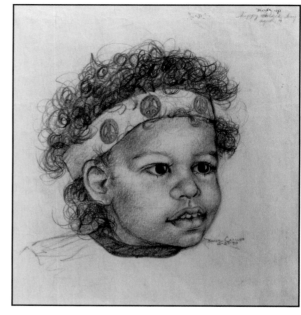

MADE-UP HIPPIE BLACK BOY, AGED 4
December 27, 1970. Graphite, 11" × 12".
Courtesy of Deborah Carrino

BEAUTIFUL NEGRO BOY
September 29, 1970. Graphite, 7½" × 9½".
Courtesy of Judge Thomas Zampino

She was a senior in my study hall [when I was a teacher at Memorial]. She was Frank Cocuzza's friend and she liked to wear those army fatigues. She had tremendous talent. I bought two pieces at the exhibit when her father sold everything. They now hang in my chambers and have graced the walls for over twenty years. They will be gifts to my daughters.

—Thomas P. Zampino

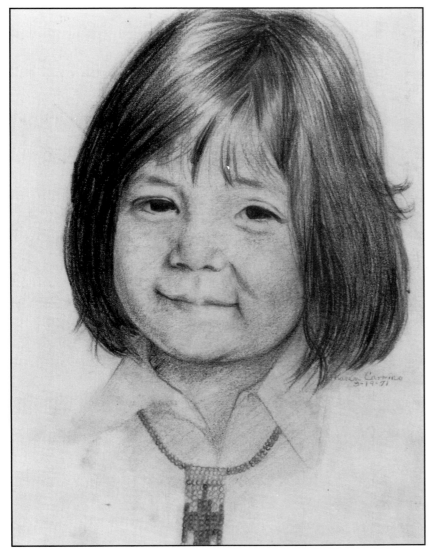

***NATIVE AMERICAN BOY —
MADE-UP***
March 19, 1971.
Graphite, 8" × 11".
Courtesy of Deborah Carrino

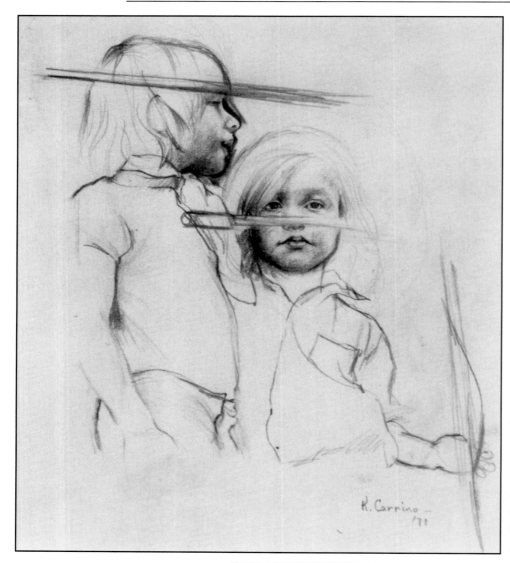

***BOYS BEHIND
MICROPHONE BARS***
*1971.
Graphite, 7½" × 9½".
Courtesy of
Doris Yambra.
Source: Circus
magazine,
December 1970*

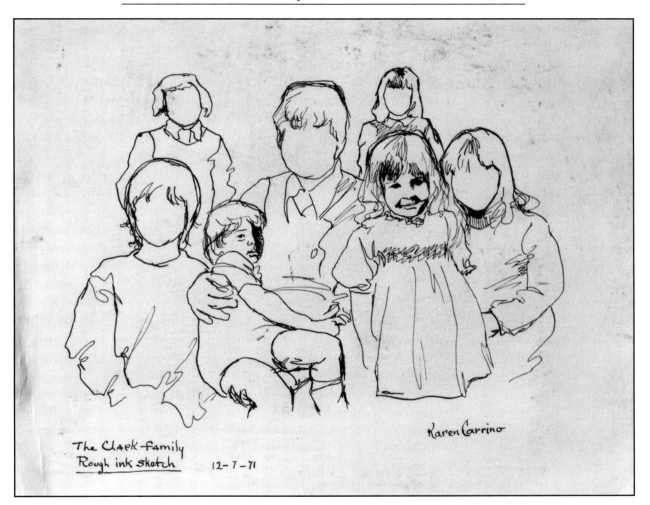

THE CLARK FAMILY—ROUGH INK SKETCH
December 7, 1971. Ink on paper, 11½″ × 9½″. Courtesy of Barbara Carrino

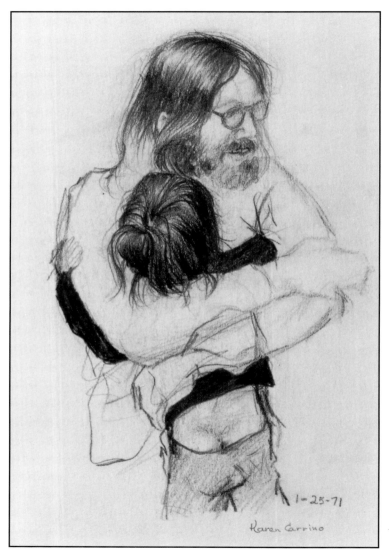

MAN HUGGING BOY
January 25, 1971. Graphite, 7" × 10".
Courtesy of Barbara Carrino

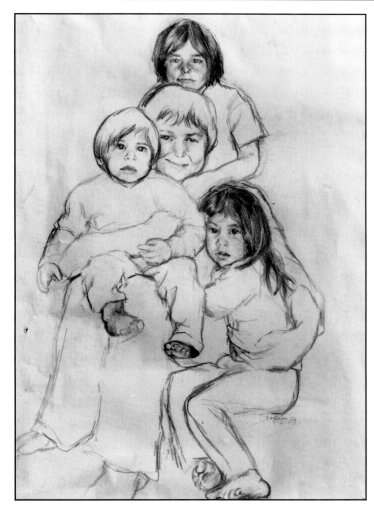

BRANDON CRUZ AND FAMILY
March 2, 1970. Graphite, 12" × 17½".
Courtesy of Sister Carmela M. Cristiano, S.C.

I did not have the pleasure of meeting Karen. I was privileged to view her various drawings when invited by her art teacher, Fabian Zaccone. When I saw these magnificent works, I was overwhelmed with their beauty and clarity. They actually looked like enlarged photos of their subjects. I was thrilled to be given some of the unfinished works for display in my child-care center, where Karen's boyfriend had worked for me. Steve was so distraught by Karen's death. He had often told me how talented Karen was and he asked me to go to the school and see the display of her work.

—Sister Carmela

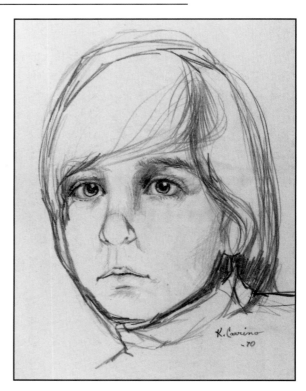

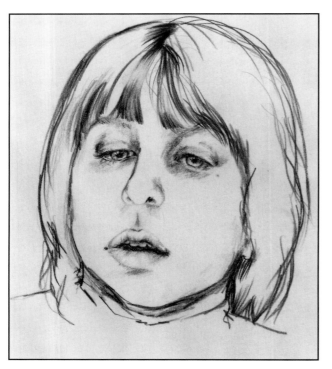

BOY LOOKING DOWN
No date. Graphite, 9¹/₂″ × 11″.
Courtesy of Ethel Carrino

LINE SKETCH OF ADOLESCENT BOY
1970. Graphite, 9¹/₂″ × 13″.
Courtesy of Ethel Carrino

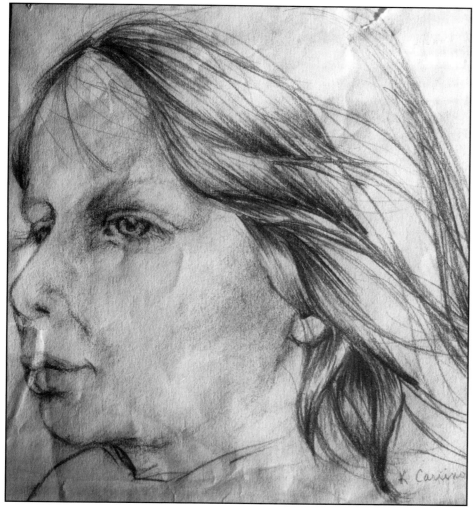

PROFILE OF MADE-UP BOY
No date.
Graphite, $7\frac{1}{2}'' \times 8''$.
Courtesy of Coleen Truscio

Karen was always talking about Michael. I asked her to bring him in one day to school so I could meet him. When she finally brought him in I wasn't there. She got mad at me. She was always teasing. I just remember that bratty laugh —not in a mean way, but just always kidding.

—Coleen Truscio,
classmate

95

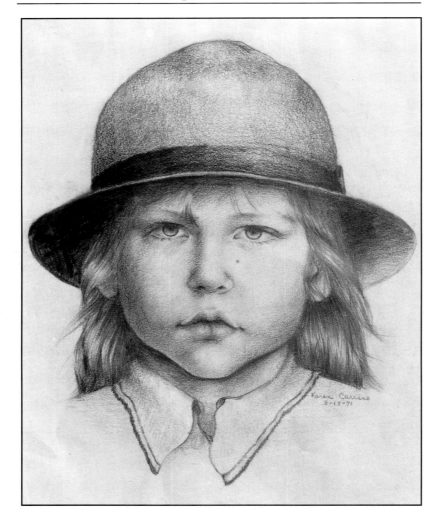

BOY WITH HAT, MADE-UP
August 18, 1971. Graphite, 11" × 14". Courtesy of Diane Hosein

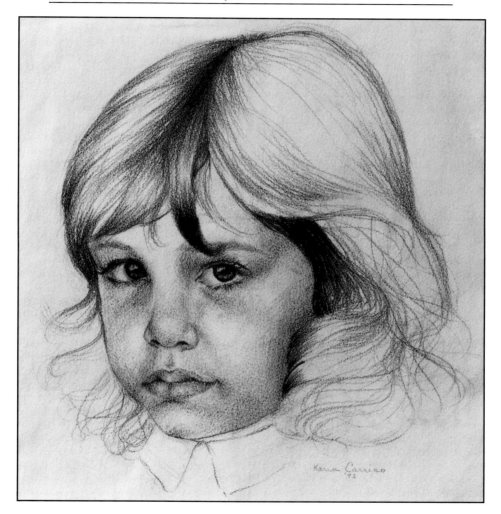

THREE-QUARTERS VIEW OF BOY
1972. Graphite, 14" × 17". Courtesy of Deborah Carrino

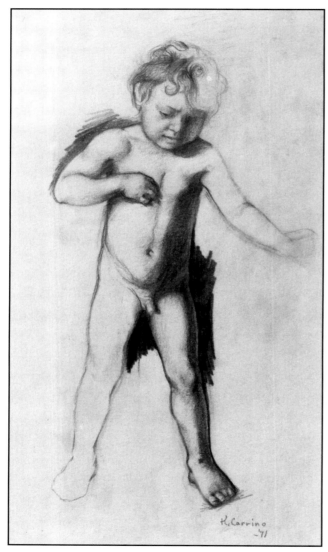

FRONT VIEW OF BOY
1971. Graphite, 6½ × 11½".
Courtesy of Doris Yambra

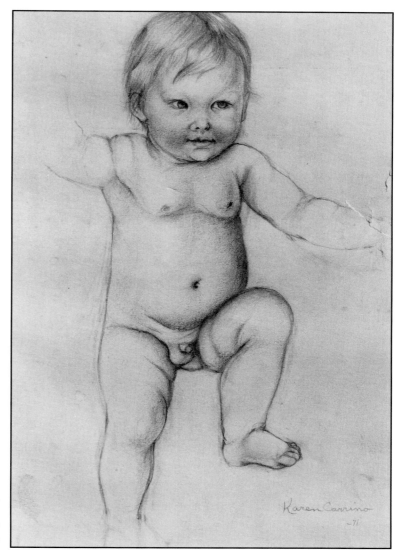

NAKED BABY
1971. Graphite, 9″ × 13″.
Courtesy of Robert Carrino

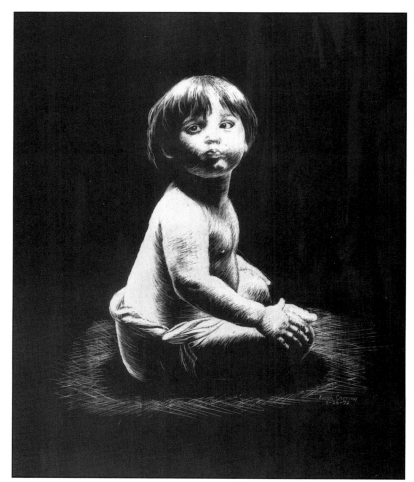

BABY LOOKING BACK
May 26, 1972.
Scratchboard, 8" × 10".
Courtesy of
Michelle Carrino-Warburton.
A gift from Tony and Nancy Mussara

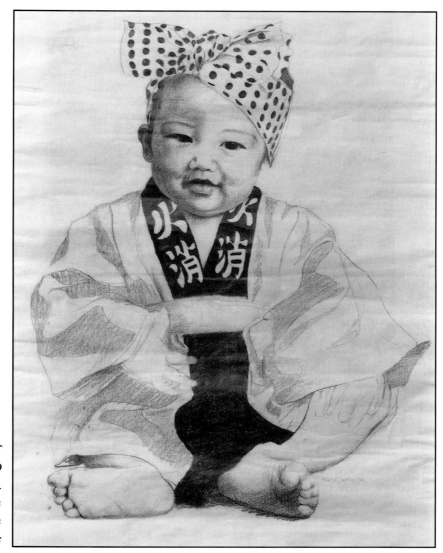

**JAPANESE BABY
IN KIMONO**
*1972. Graphite, 18" × 24".
Courtesy of Micki Najemian
Source: Japan Air Lines ad from*
Esquire *magazine*

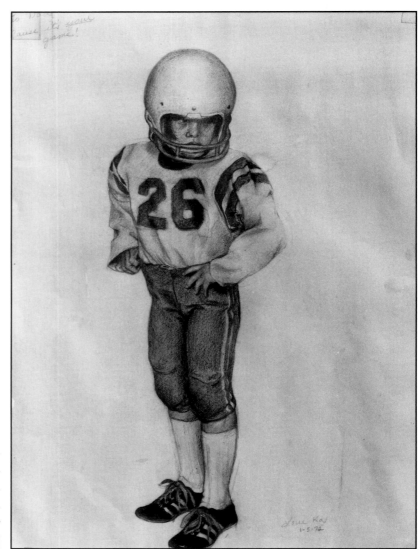

BOY IN FOOTBALL GEAR
January 5, 1972.
Graphite, 11½″ × 15½″.
Courtesy of Robert Carrino.
A gift from Edward Delaney
[To Dad, Cause it's your game]

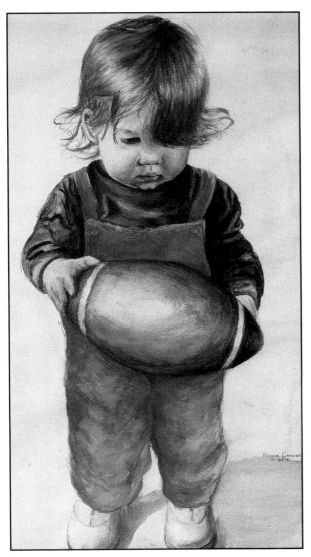

BABY WITH FOOTBALL
November 23, 1971. Watercolor,
10½" × 20". Courtesy of George Polazzi

Karen made a real impact on me. After she moved with her family to West New York, she would drop in to visit me at Weehawken High School. Karen gave me the few paintings and sketches I have. The Paul McCartney drawing was a special gift because she knew I liked the Beatles. She was an extraordinarily talented and prolific!
—George Polazzi, art teacher

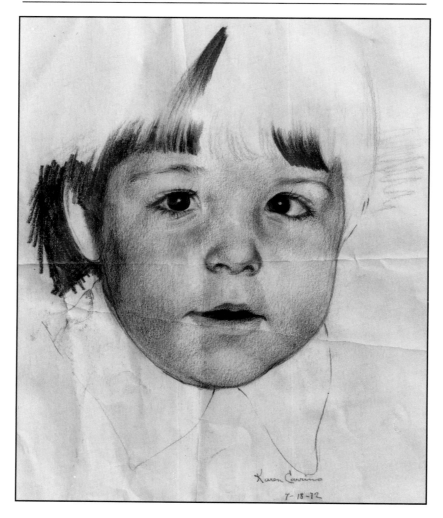

BOY WITH TURNED EYE
July 18, 1972. Graphite, 9½″ × 11½″. Courtesy of Ethel Carrino

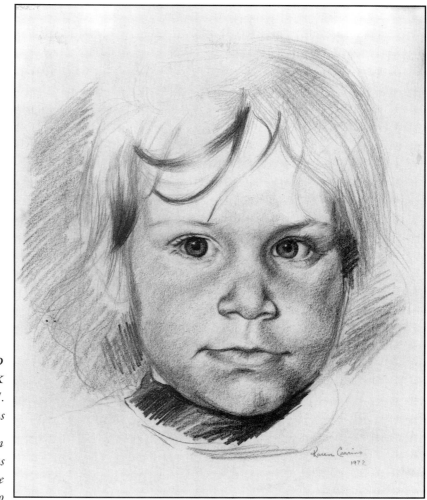

**UNFINISHED CHILD
IN TURTLENECK**
*1972. Graphite, $10^1/_2'' \times 13^1/_2''$.
Courtesy of Juliet Obsteins*

I didn't really know her. I was an aspiring artist and I thought she was excellent. I bought the piece at the exhibit. I was a younger artist who hoped to be like her.

—Juliet Obsteins

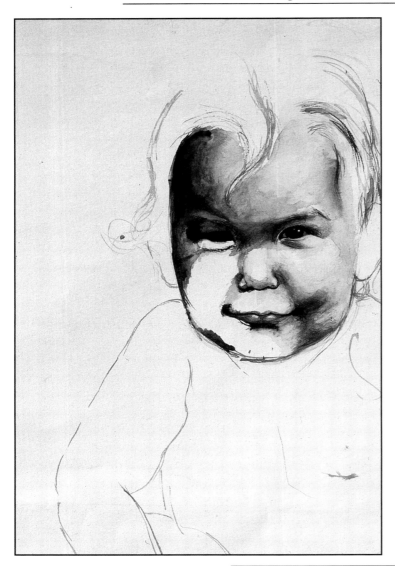

TODDLER SMILING
No date. Watercolor, 7½" × 11".
Courtesy of Dr. Charles Konia

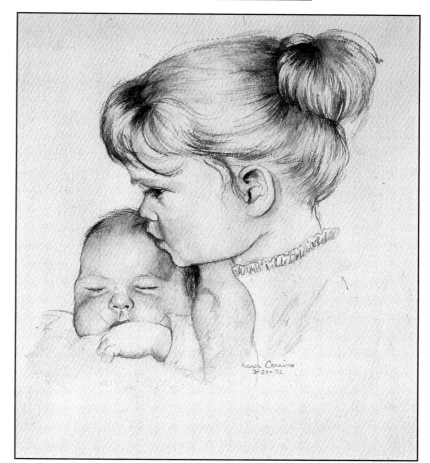

GIRL WITH BABY
March 24, 1972.
Watercolor, 12" × 13½".
Courtesy of Carol Cutitta

I asked Karen if I could buy this drawing of a little girl she had done because it looked just like my niece. Karen said she didn't like to sell her work, but that I could just have it. What a beautiful gift. Her work was incredible. She was so talented—I can just imagine what she'd be doing today.

—Carol Cutitta, teacher

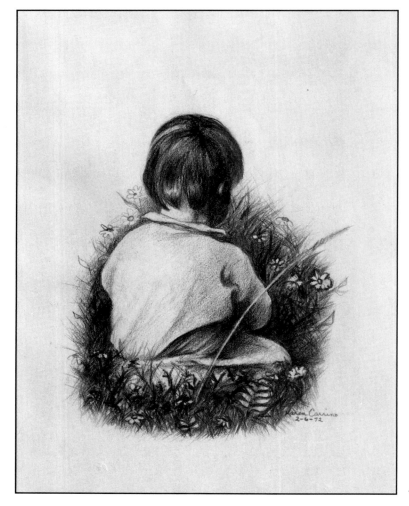

BABY IN GRASS
February 6, 1972. Graphite,
7½" × 10". Courtesy of Jane Bace

Karen was a good friend. She had a lot of responsibility. She was serious about her work and family, way beyond her years, though she never complained. She had great dreams for her future (and Michael's). She could have done really amazing things.

—Jane Bace, classmate

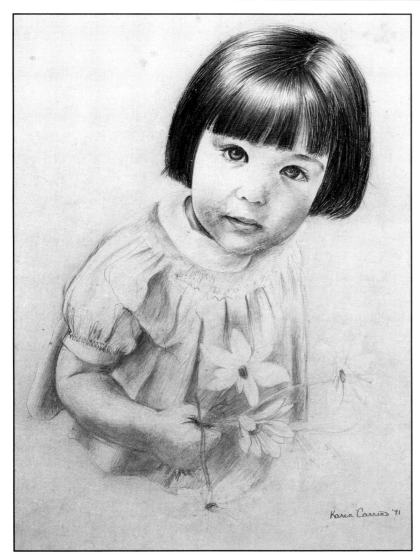

GIRL WITH DAISIES
1971. Color pencil on poster board,
15" × 19½".
Courtesy of Robert Carrino.
Source: A Blue Cross ad from
Life *or* Look *magazine.*
A gift from
Mr. and Mrs. Paul Madison

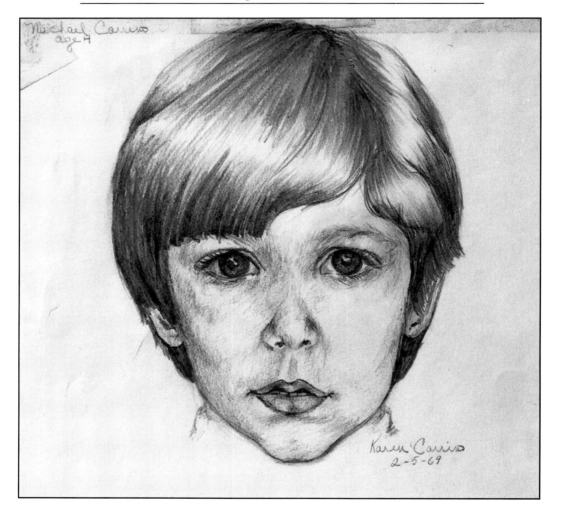

MICHAEL CARRINO, AGED 4
February 5, 1969. Graphite, 10½" × 11½". Courtesy of Barbara Carrino

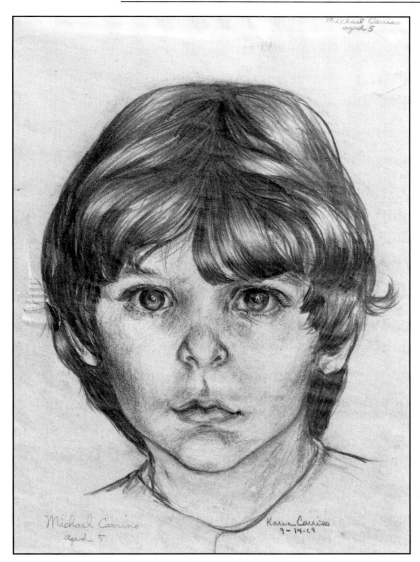

MICHAEL CARRINO, AGED 5
September 14, 1969.
Graphite, 10″ × 12½″.
Courtesy of Joan Carrino

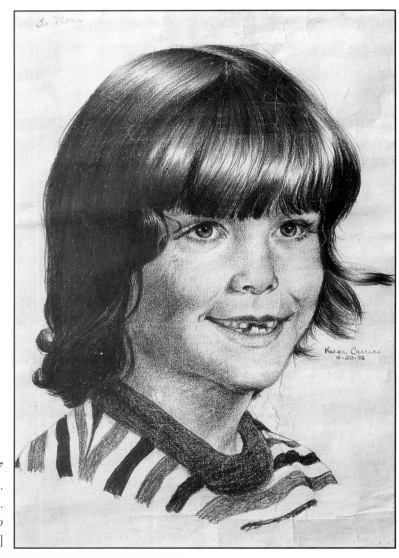

MICHAEL, AGED 7
April 20, 1972.
Colored pencil, 8½" × 12".
Courtesy of Ethel Carrino
[To Mom]

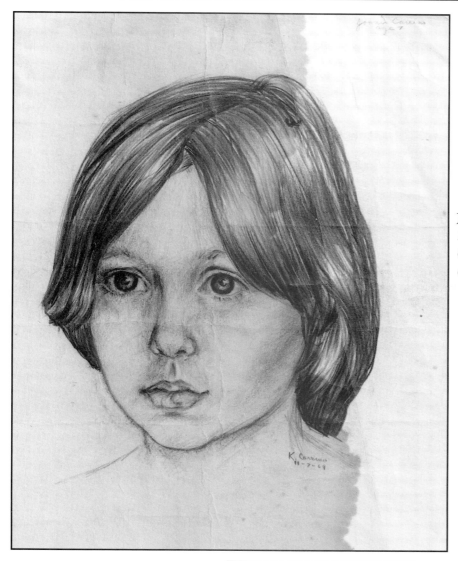

JOANIE CARRINO, AGED 7
November 7, 1969.
Graphite, 12" × 17".
Courtesy of Irene Carrino

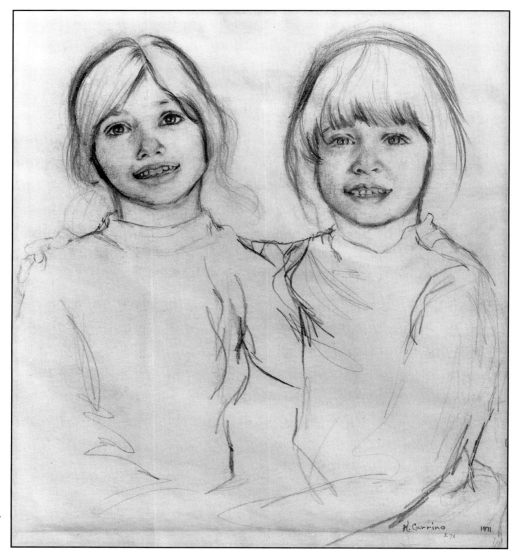

**JOAN AND
MICHAEL #1**
*1971. Graphite,
11½" × 15½".
Courtesy of
Joan Carrino*

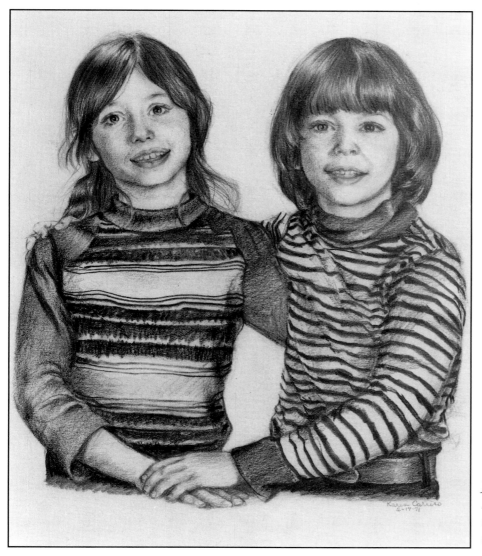

JOAN AND MICHAEL #2
February 17, 1971.
Graphite, 11" × 15".
Courtesy of Joan Carrino

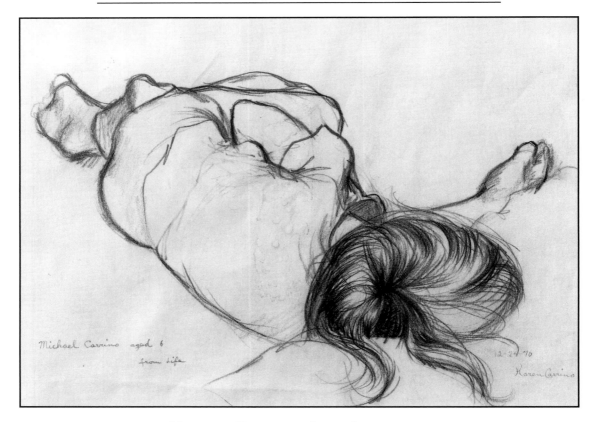

MICHAEL CARRINO—AGED 6 FROM LIFE
December 24, 1970. Graphite, 15″ × 10½″. Courtesy of Tony Borotto

Whenever I look at this particular drawing, I cannot help but marvel at the poignancy and sensitivity of the body of work created by Karen Carrino. Although I knew her father, Robert, I did not know Karen personally. I believe that those of us who did not know her missed meeting someone very unique and special. But, we have her work and that will live on as a reminder of that person, her feelings and her emotions. For that, we are all very fortunate.
—Tony Borotto

MICHAEL CARRINO, AGED 6
December 24, 1970. Graphite, 15" × 11". Courtesy of Deborah Carrino

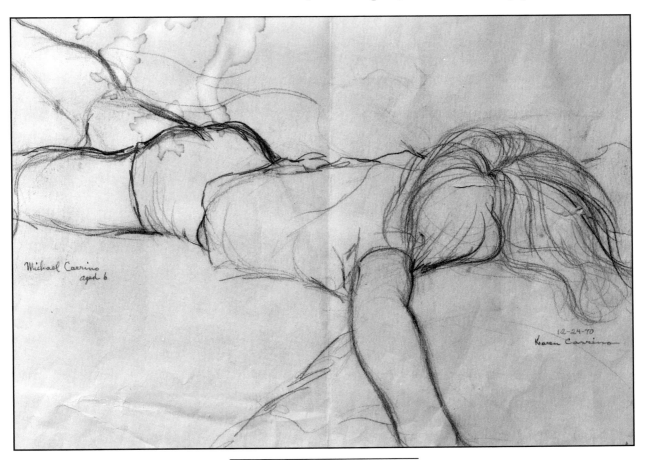

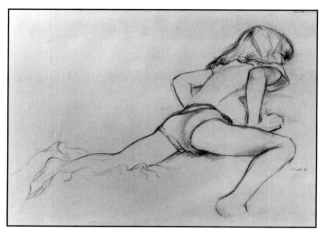

MIKE
October 28, 1971. Graphite, 15½" × 11½".
Courtesy of Deborah Carrino

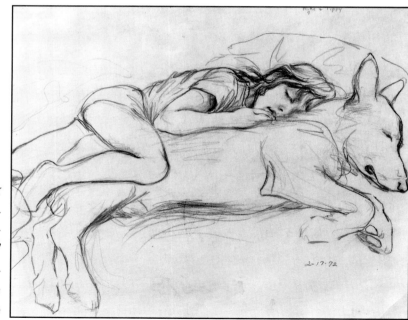

MIKE (7) AND TIPPY
February 17, 1972.
Graphite, 13½" × 11".
Courtesy of Anne Erb

Karen's gentle manner and love for children are depicted in this and many other of her works. —Anne Erb

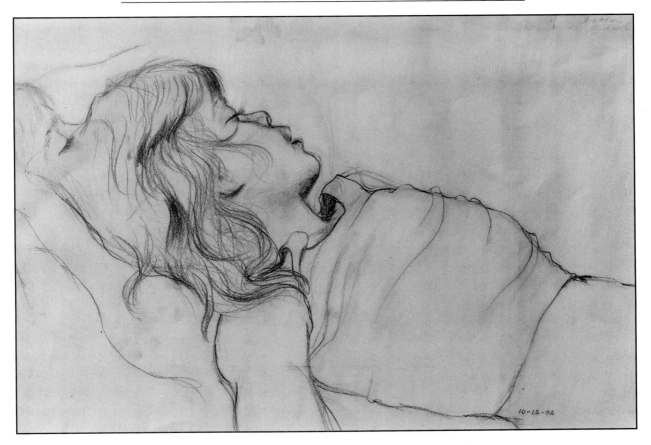

LIFE SKETCH OF MY BROTHER MICHAEL
October 12, 1972. Graphite, 13½″ × 11″. Courtesy of Joan Carrino

TOM KOSIS, 2¹/₂ YEARS OLD
December 13, 1970.
Oil on canvas board, 12" × 16".
Courtesy of Tom Kosis

ROBERT AND MICHAEL
November 26, 1970.
Graphite, 14" × 16".
Courtesy of Mary Ariemma

Although I did not know Karen personally, I can see the love in her heart for children through her work. The sketch she made of my twin sons, which was a gift from my sister, who went to school with Karen, hangs on my wall with great pride. Each time I look at it my heart fills with love and sorrow. Sorrow only because I never had the chance to meet Karen and thank her for the joy she has brought to me with her work. Everyone who sees this sketch marvels at this great work of art. She will live in my thoughts forever.
—Mary Ariemma

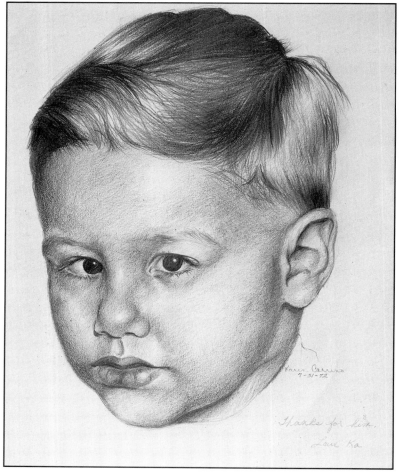

STEVE MILLER
July 31, 1972. Graphite, 10½" × 13½".
Courtesy of Mrs. Elizabeth Miller
[Thanks for him, Love Ka]

In the short time we knew Karen, we became very fond of her. She was a loving, caring, and talented young woman. In our hearts she will always be remembered.

—Mrs. Elizabeth Miller

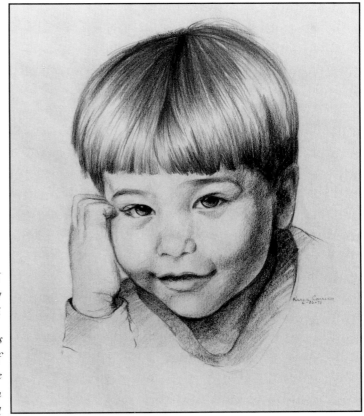

GINO PAGNOZZI

June 16, 1971. Graphite, 12" × 16". Courtesy of Lois and Gene Pagnozzi

Karen did a drawing of our son when he was two years old from a photograph. I was in awe of the vitality about her—she came alive when she was doing her art. I was a physical education teacher. I had seen some of her work—she carried it around with her. The thing that impressed me was the eyes. She had a page in her sketch pad that was just eyes. It blew me away that a kid could do that. I asked her if she could draw my son, Gino. She captured him so well. This [her death] was such a tragedy. At times she would be quiet—and at other times she would liven up, especially when talking about her artwork.

—Gene Pagnozzi, teacher

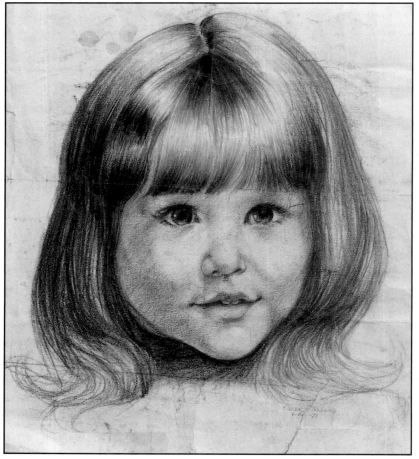

CATHLEEN
January 24, 1971.
Graphite, 10" × 12".
Courtesy of Maureen Mucha

Karen touched all of us. She was such a sweet person. It was such a shock to me when she died and seeing the pictures in the paper brought back so many feelings. She didn't hang around with the cliques at school but everyone knew her. She was always sketching on the steps in front of the school. I asked her if she could sketch a picture of my little sister and she did a quick sketch, right in health class. She was very quiet. I was a bigmouth. She told me at the end of school that when she first met me, she didn't know how to take me.

—Maureen Mucha, classmate

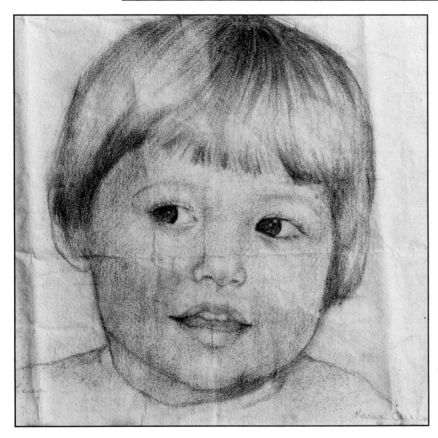

LISA BOUDRIE
October 12, 1971.
Graphite, 9½" × 13".
Courtesy of John Boudrie

She was so exceptional. I can still feel her presence.
—Millie Boudrie
(now deceased, quoted from an interview
with the Associated Press, August 1997)

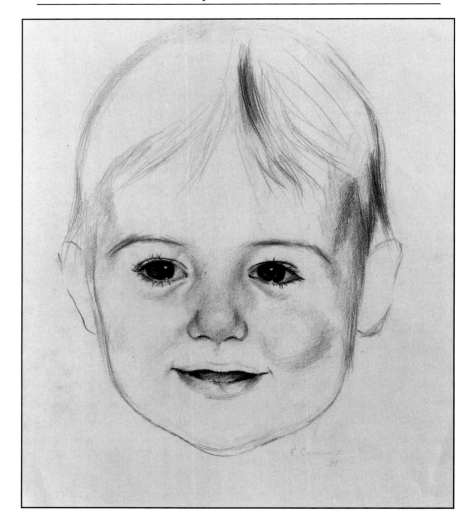

KIM FERRAINOLO—FIRST SKETCH
1971. Graphite, 10″ × 12″. Courtesy of Barbara Carrino

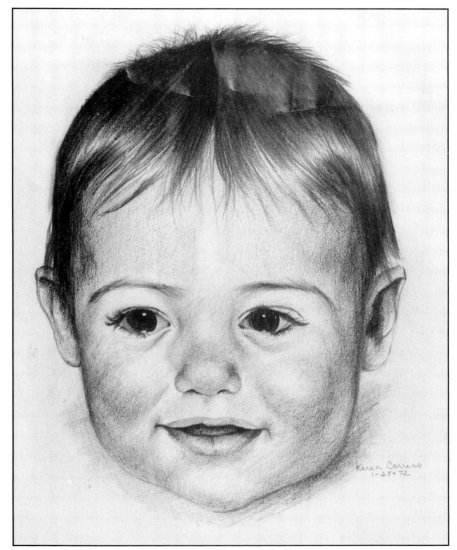

KIM FERRAINOLO
January 25, 1972.
Graphite, 13½" × 14".
Courtesy of
Rosemarie Ferrainolo

My husband was a teacher at Memorial High School and we knew the Pagnozzis. We were over their house one night and I was amazed at the drawing Karen had done of their son, Gino. It looked just like him. I asked my husband to ask Karen to do a drawing of our daughter and I would pay her for it. We did pay her, I think, $25.00. It looked just like Kim. I'm an art teacher and I can't do drawings like that. She was incredible. I wish I had known her. I wanted her to do our other daughter but she had died.

—Rosemarie Ferrainolo,
teacher

127

MARK DAVID MADISON, AGED 3½ MOS.
November 3, 1970. Graphite, 8½" × 11". Courtesy of Paul and Pauline Madison

Karen was just a real human being—very open. She'd just tell you what was on her mind in a real nice way. She'd just express herself. The first time I met her was in my study hall. I found out she was an artist and I recognized her talent. I asked her to draw something that represents spring and she drew the little girl with daisies. She was definitely an individual and so am I, and I think we could relate because of that. She wasn't prejudiced at all. She baby-sat for my children.

—Paul Madison, teacher

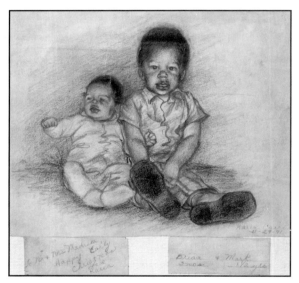

BRIAN 3 MOS. AND MARK 1½ YRS.
November 29, 1971. Graphite, 8" × 6½".
Courtesy of Paul and Pauline Madison
[To Mr. and Mrs. Madison,
Happy Early Christmas, Love Karen]

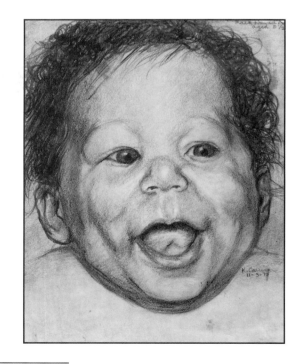

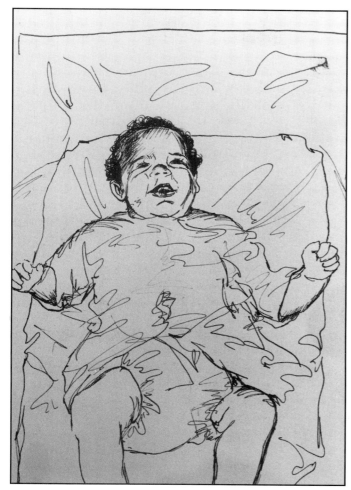

BRIAN PAUL MADISON, AGED 3 MOS.
December 5, 1971. Ink, 8" × 11"
[First ink sketch]

People used to get mad at her because she walked around in that hat and those khaki clothes, but that was just her style. That was her. She had her own way about her.

—Pauline Madison

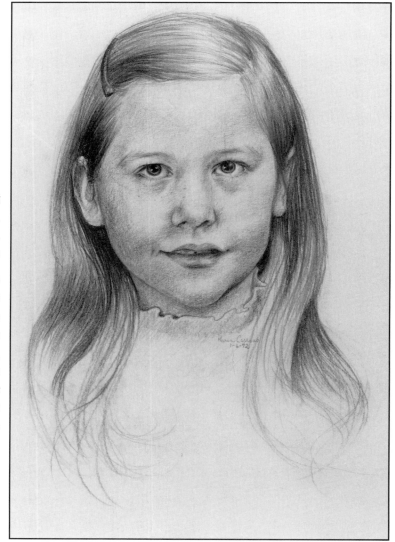

CORRINE
January 6, 1972.
Graphite, 11″ × 15″.
Courtesy of Scotti and Charles Mussara

When Karen did the drawing of my daughter Corrine, she told me she wasn't happy with it. She said that the cheeks were too puffy and she wanted to take it back to fix it. I said it looked fine, but she insisted, so I told her whenever she had the time, she could work on it. Unfortunately, as things turned out, she never got her chance to fix the drawing. —Scotti Mussara

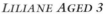

LILIANE AGED 3
April 21, 1971.
Graphite, 12½" × 11½".
Courtesy of Liliane Miller

Karen was my best friend. We found each other through our mutual love of art, Beatles (she—John, me—Paul), and humor. We saved each other for a while from going insane. While we would spend time drawing together and debating who was the best Beatle (it was a draw), the memory I cherish most is the laughter, all we did was laugh—at each other and mostly at other people. She was truly the first genuinely, inherently funny person I knew. She shared my tilted and warped views of the wrong and wrung it inside out. She even taught me how to spit so hard that "it would put a hole through you"—her words.

I miss her terribly and her absence left a great void in my life. I wish that night never happened; you and Michael are missed.

—Liliane Miller, friend and classmate

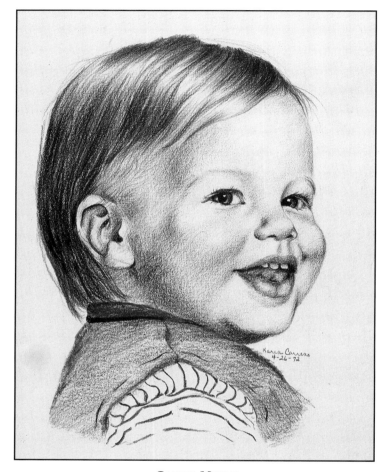

JAMES MEILO

April 26, 1972. Color pencil, 11" × 14". Courtesy of John and Joyce Meilo

Karen—a gentle person floating on the wind, her artistic talent touching you like a feather on the brow, pleasant and soft—I remember. —John Meilo

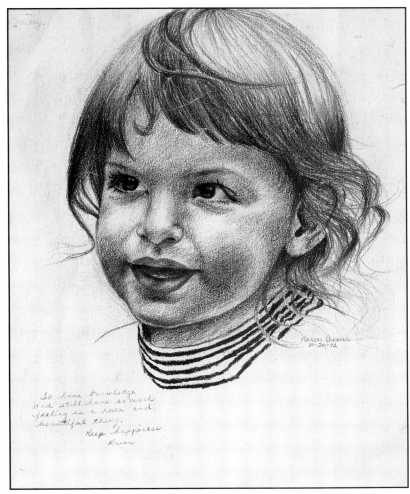

SIAN
October 26, 1972.
Color pencil, $10\frac{1}{2}" \times 13"$.
Courtesy of Sianna Beckwith
[To Molly, —To have knowledge and still have so much feeling is a rare and beautiful thing.
Keep happiness, Karen]

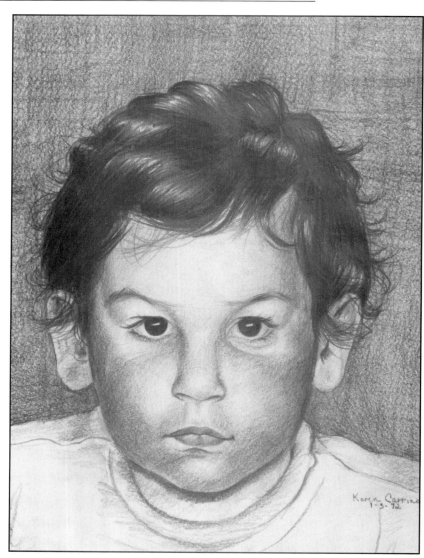

JASON RAND
January 3, 1972.
Graphite, 8½" × 11½".
Courtesy of Daryl Rand

MICHAEL ZACCONE, 2½ YEARS OLD

February 6, 1972. Graphite, 12" × 14½".
Courtesy of Carol and Edmond Zaccone

"There was so much she could have done. She had such talent. She was like a member of my family and I'm especially fond of the drawing she did of my grandson, Michael. Her sensitivity remains visible through her work. Her signature became that strange look of innocence on a young face. She will never go on to achieve the honors in the Art world that seemed to be her destiny, but she will not be forgotten."

—Fabian Zaccone, Karen's art teacher (now deceased, quoted in the *Hudson Dispatch*, January 1973)

My memories of Karen are of a serene young lady who had a tremendous love and empathy for the children that surrounded her and became her models. Great artists cannot execute their works without this involvement in their subjects. Karen did so with an intensity beyond her years. My father's words were prophetic when he made them because Karen has been recognized over time as being a great artist. —Edmond J. Zaccone

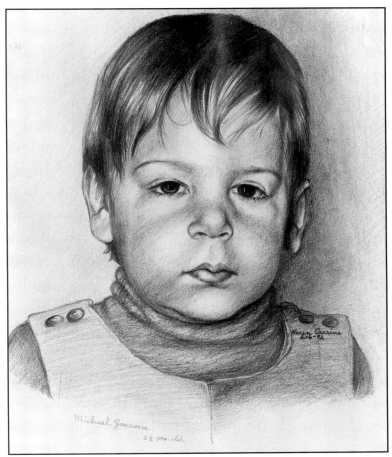

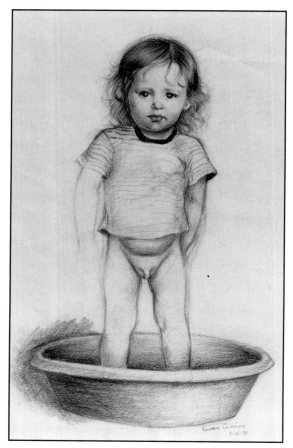

DONOVAN
January 16, 1971. Graphite, 11½″ × 16½″.
Courtesy of Joan Carrino.
Source: Donovan's Greatest Hits *album*

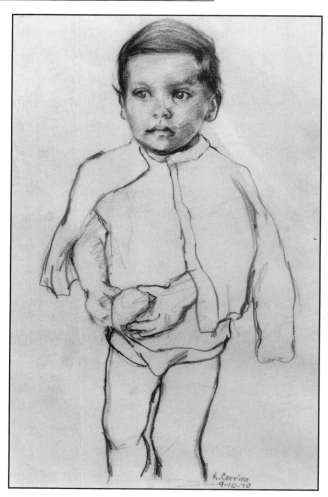

CARLO PONTI JR.
September 10, 1970. Graphite, 9″ × 14″.
Courtesy of Deborah Carrino

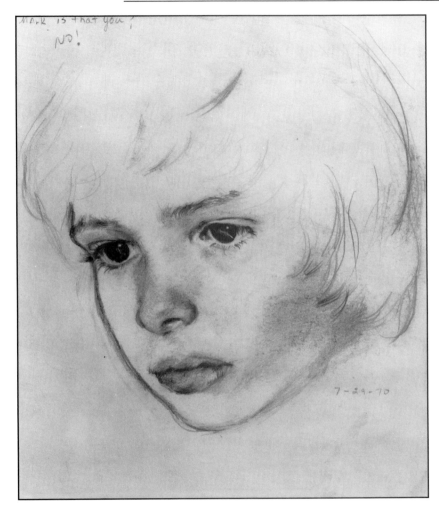

MARK LESTER
July 29, 1970.
Graphite, 10" × 12".
Courtesy of Deborah Carrino.
A gift from Fabian Zaccone
[Mark is that you? No!]

"This was the worst tragedy of my art career. I have had many students that became well-known artists, but none of them touched what Karen was. She was so gifted. She would certainly have become a great artist."
—Fabian Zaccone,
Karen's art teacher

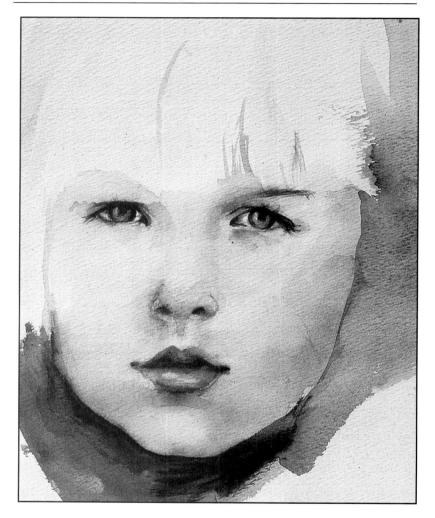

HEATHER MCCARTNEY
No date. Watercolor, 7½" × 9½". Courtesy of Judge Thomas Zampino

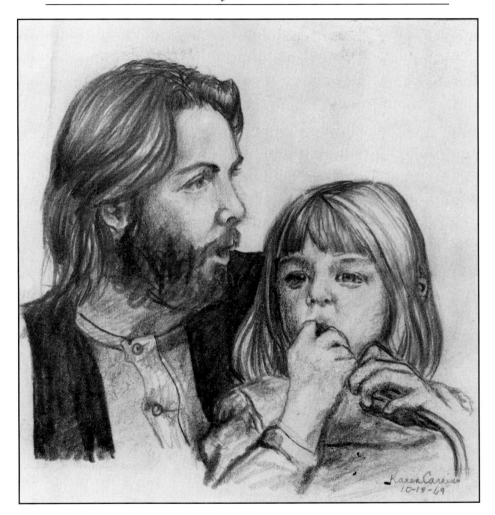

MCCARTNEY AND HEATHER
October 18, 1969. Graphite, 10" × 10½". Courtesy of Diane Hosein

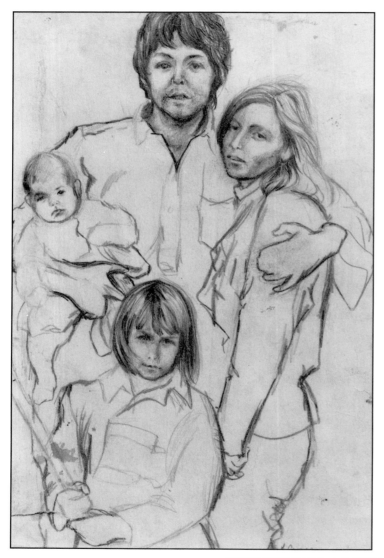

MCCARTNEY AND FAMILY
November 19, 1969. Graphite, 10" × 15".
Courtesy of Elizabeth Kinney
Source: Life *magazine, November 7, 1969*

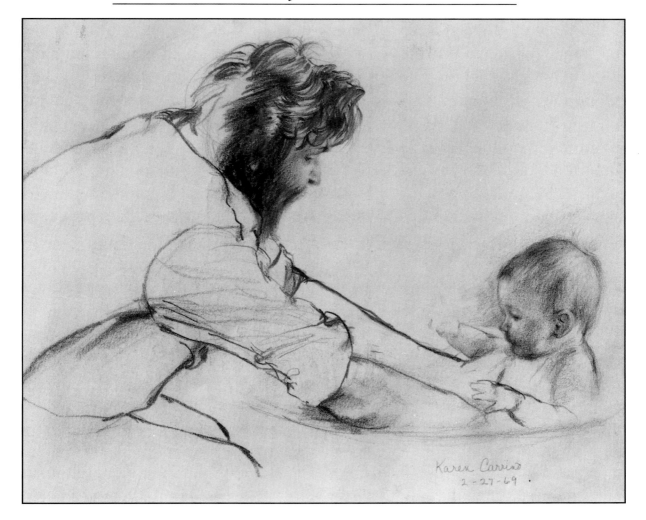

PAUL BATHING MARY
February 27, 1969. Graphite, 10" × 8". Courtesy of Barbara Carrino

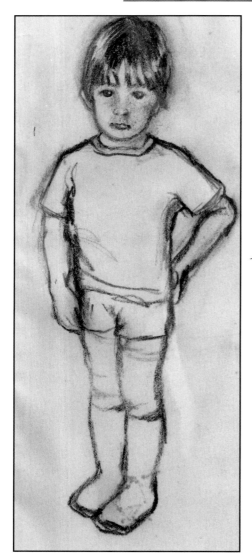

JULIAN LENNON—HAND ON HIP
October 29, 1968. Graphite, 4½" × 10". Courtesy of Ethel Carrino

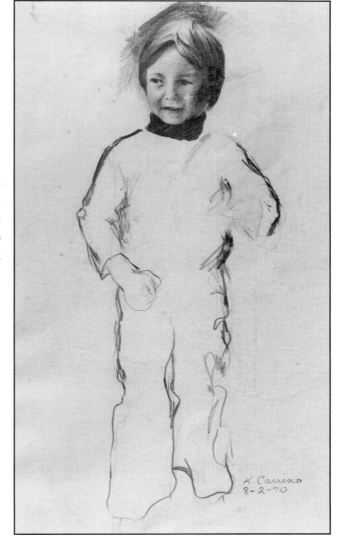

JULIAN LENNON AGED 6
August 2, 1970. Graphite, 9" × 13".
Courtesy of Dr. Charles Birk
Source: John Lennon and Yoko Ono
Their Love Book

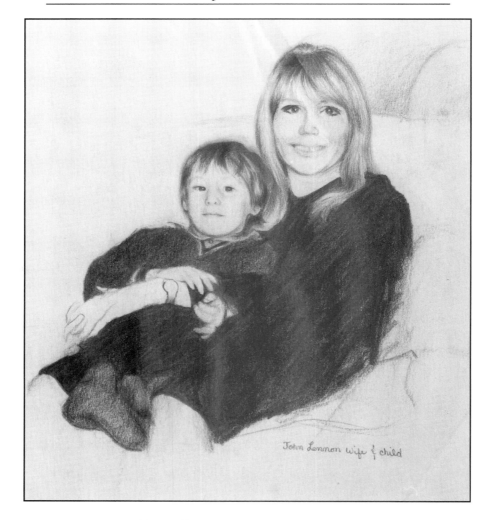

JOHN LENNON WIFE AND CHILD
No date. Graphite, 9″ × 11″. Courtesy of Michelle Carrino-Warburton

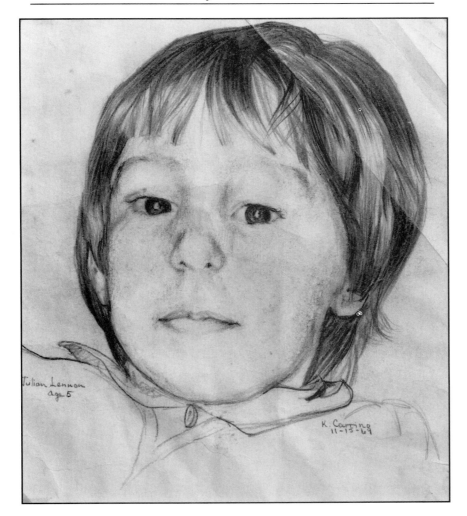

JULIAN LENNON AGED 5
November 15, 1969. Graphite, 9″ × 10″. Courtesy of Ethel Carrino

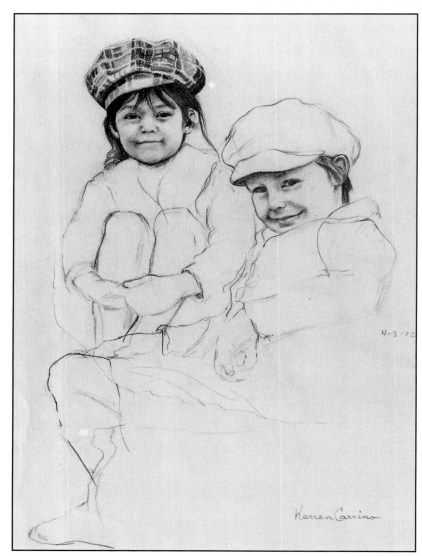

Kyoko and Julian
April 3, 1972. Graphite, 9" × 13".
Courtesy of Barbara Carrino
Source: John Lennon and Yoko Ono
Their Love Book

THE JULIAN LENNON FAMILY
June 19, 1970. Ink, 6" × 7".
Courtesy of Barbara Carrino

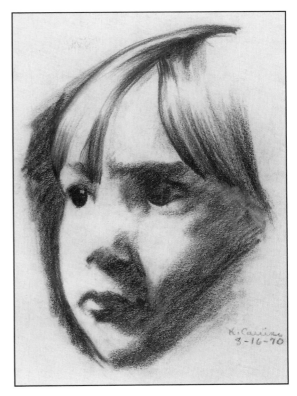

JULIAN LENNON, JOHN'S SON (AGED 8)
August 16, 1970. Graphite, 8" × 10". Courtesy of Frank Cocuzza

Karen found it difficult to conform even to the most trivial of high school rules. The pressures of her peers or the expectations of her teachers meant little. She was a free spirit, an artist. She sat in my classes, bent under a man's brown fedora, sketching while her classmates took notes on the lessons. And although she professed interest in the literature being discussed, wonderful children sprang to life on her pad. I was delighted to have my tolerance rewarded occasionally with a drawing left on my desk or handed to me in study hall. They have become cherished possessions.

—Frank Cocuzza, teacher

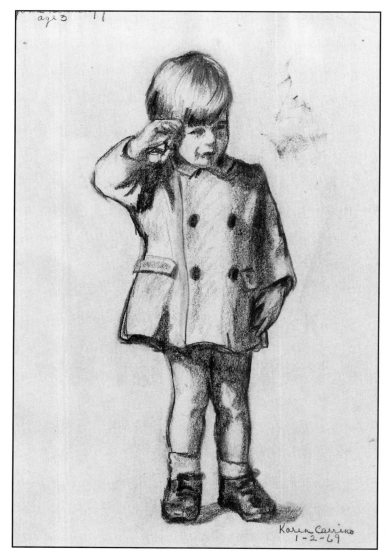

JOHN KENNEDY JR., AGED 3
January 2, 1969. Graphite, 8½" × 11".
Courtesy of Dr. Charles Birk

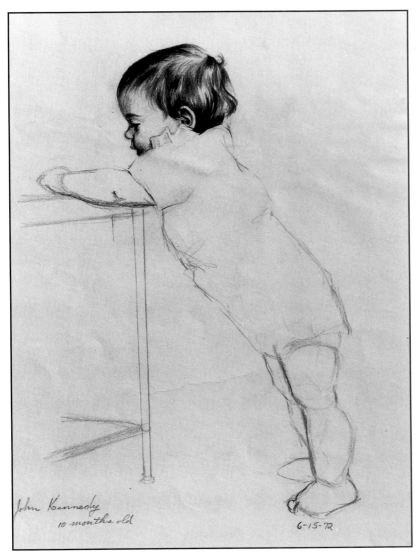

John Kennedy
10 months old

6-15-72

**JOHN KENNEDY JR.,
10 MONTHS OLD**
June 15, 1972.
Graphite, 13″ × 16½″.
Courtesy of Joan Carrino
Source: The John F. Kennedys
by Mark Shaw

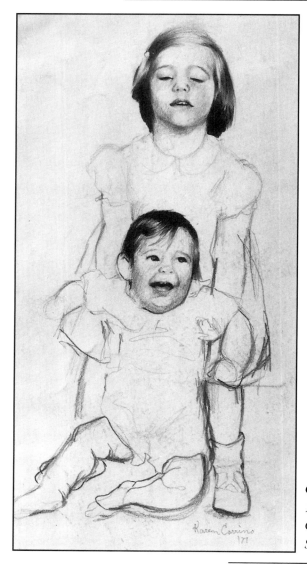

CAROLINE AND JOHN
1971. Graphite, 7" × 12".
Courtesy of Barbara Carrino
Source: The John F. Kennedys *by Mark Shaw*

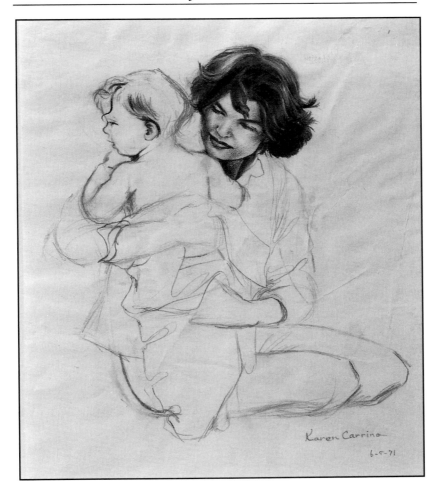

JACKIE AND CAROLINE
June 5, 1971. Graphite, 10" × 13". Courtesy of Barbara Carrino
Source: The John F. Kennedys *by Mark Shaw*

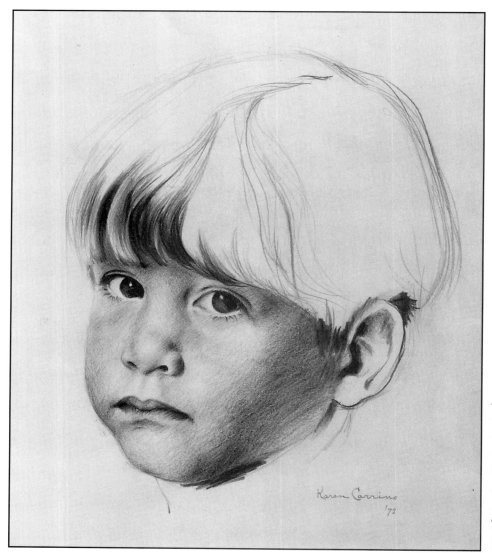

JOHN KENNEDY JR.—
FACE
1972. Graphite,
11″ × 12″.
Courtesy of
Barbara Carrino
Source:
The John F. Kennedys
by Mark Shaw

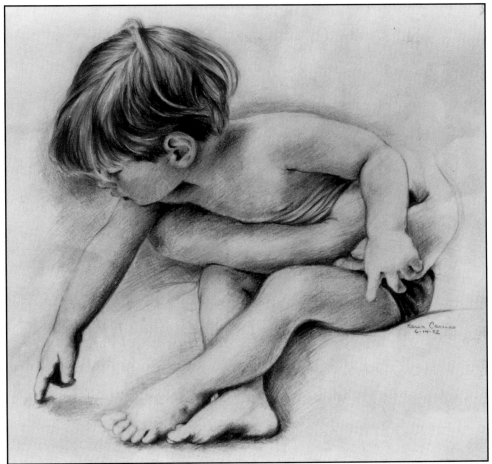

**JOHN KENNEDY,
AGED 2**
June 14, 1972.
Graphite, 17" × 14".
Courtesy of
John J. Grossi Jr.
Source:
The John F. Kennedys
by Mark Shaw

*Karen would come to
see me and wait outside
my office until I was
done with my clients
and then she would
come in and talk to me. We talked about all kinds of things but mostly her work. She would bring
sketches for me to see. We became friends. I thought she was quite remarkable.*

—John Grossi Jr.

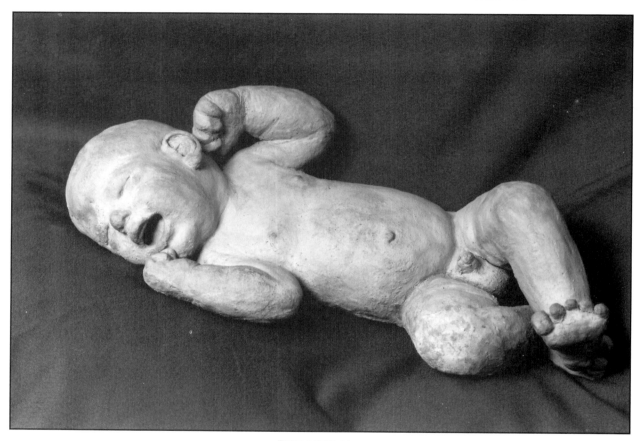

BABY JULIAN

April 11, 1972. Clay sculpture, W16" × H5" × D8". Courtesy of the Carrino Family
Source: U.S. Savings Bonds ad

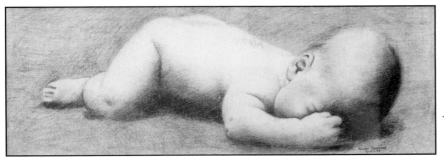

CRYING BABY #2
March 31, 1972.
Graphite, 9″ × 24″.
Courtesy of Stephen Hooks

Regrettably, I only met Karen a few times, but on those occasions I was struck by her as a person, best described as inspired. I received a personalized sketch from her that I still cherish today.

—Stephen Hooks

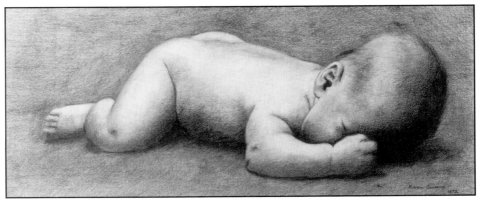

CRYING BABY #1
January 11, 1972. Graphite, 23½″ × 10½″.
Courtesy of Deborah Carrino. A gift from the Zaccone family.

She never talked about her art, she just did it.

—Fabian Zaccone, Karen's art teacher
(now deceased, quoted in the *New York Times*, December 1991)

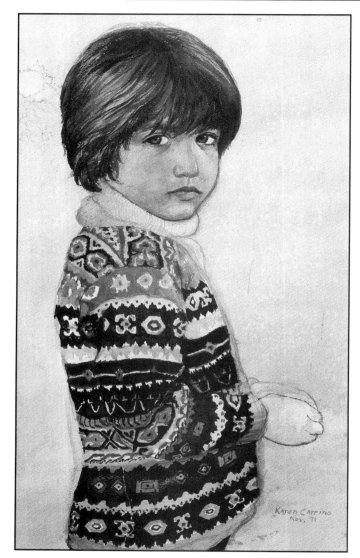

BOY IN SWEATER
November 1971. Watercolor, 11½" × 18½".
Courtesy of Joan Carrino

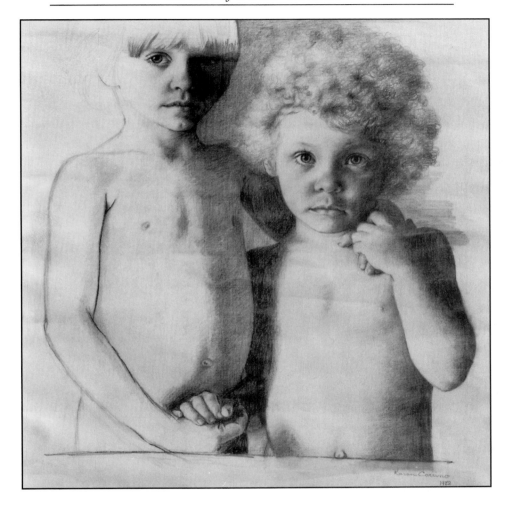

FRIENDS
1972. Graphite, 16½" × 17". Courtesy of Deborah Carrino.
A gift from Ellspeth Corrigan

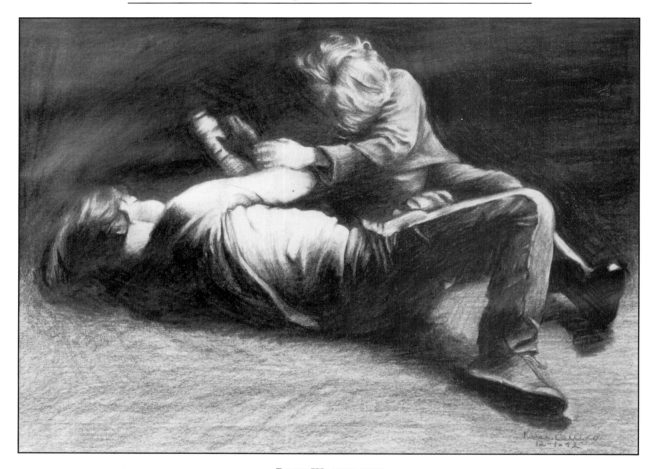

BOYS WRESTLING
December 1, 1972. Graphite, 14½″ × 10½″. Courtesy of Deborah Carrino.
A gift from Frank Cocuzza. Source: The Summerhill Book